IMAGES
of America

MAMAKATING

On the cover: Masten Lake was a popular summer destination for year-round and seasonal residents alike. In addition to boating and swimming, the casino also held many dances and events and was considered one of the best entertainment destinations in the area. (Courtesy of Phyllis M. Norton.)

IMAGES of America
MAMAKATING

Monika A. Roosa

Copyright © 2007 by Monika A. Roosa
ISBN 978-0-7385-5471-6

Published by Arcadia Publishing
Charleston SC, Chicago IL, Portsmouth NH, San Francisco CA

Printed in the United States of America

Library of Congress Catalog Card Number: 2007902096

For all general information contact Arcadia Publishing at:
Telephone 843-853-2070
Fax 843-853-0044
E-mail sales@arcadiapublishing.com
For customer service and orders:
Toll-Free 1-888-313-2665

Visit us on the Internet at www.arcadiapublishing.com

This book is dedicated to my mom, Hannelore Lavicska.

Contents

Acknowledgments 6

Introduction 7

1. Business and Industry 9

2. Homes and Street Scenes 37

3. Community Services 63

4. Notable Events 79

5. Recreation 91

6. Schools and Places of Worship 109

7. Transportation 121

ACKNOWLEDGMENTS

There are many people whose help has been invaluable to me in preparing this book. First and foremost, I would like to thank my husband, Michael, for encouraging me to complete a project that I have wanted to do for many years, for his guidance and patience, and for his editing skills. I would also like to thank the local historical society volunteers who provided me with much of my background material: John Masten, town of Mamakating historian; Loretta Franklin, village of Bloomingburg historian; Gwen Deserto and Judy Stamm of the Bloomingburg Restoration Foundation; and Carol and Diana Ice, Burlingham area historians.

Most importantly, I would like to thank all of the Mamakating residents who loaned me photographs from their private family collections and for sharing their stories about what used to be. Those are some of the best memories I have taken away from this project. The greatest part of this book is that it was truly a community effort.

During my project research, I discovered many wonderful historic photographs from all over Mamakating. The most difficult part of this job was selecting only a fraction of them for publication. My hope is that this book renews public interest in our local history and stirs people to go out and discover it for themselves. It really is fascinating.

INTRODUCTION

The picturesque town of Mamakating can be found in the southeastern portion of Sullivan County. It is populated on either side of the Shawangunk mountain range, which forms the ridge separating the Catskill Mountains from the Hudson valley.

Mamakating's existence dates back to 1788. It was the first township of Sullivan County, as it predated the county by many years. In fact, the first non–Native American settler of Sullivan County, Manuel Gonsalaus, built his cabin alongside the Old Mine Road (present-day U.S. Route 209) around 1700. His burial site on the grounds of the Wurtsboro Airport is still visible today.

In 1825, modern corporate America came to Mamakating in a big way. On July 13 of that year, citizens from the tricounty area descended upon Mamakating to witness the groundbreaking of the Delaware and Hudson Canal, which was about to make history as the first private corporation in America capitalizing at $1 million. The canal had a huge impact on Mamakating, from infusions into the local economy to naming towns. In those days, it was considered a corporate perk for employees of the canal company to have communities named in their honor. Thus the village of Rome was renamed Wurtsborough in honor of Maurice Wurts, the company president; and Phillipsport was named in honor of Phillip Hone, mayor of New York City and a major financer of the canal. Beatysburg had its named changed to Summitville, as that area represented the highest point, or summit, of the canal route.

Mamakating prospered and grew exponentially during the 70 years of canal operations. Near the end of the canal's reign, the steam locomotive began making inroads to Sullivan County, first as competition against the canal, and later to bring vacationers to the area from New York City. As the gateway to the Sullivan County Catskills, Mamakating was the first stop for rest and relaxation in the mountains. There was an abundance of hotels and rooming houses for travelers looking to experience Mamakating's wealth of activities. Hunting, fishing, swimming, boating, and scores of other diversions awaited the thousands of visitors to the area each summer.

Although the railroads began their decline in the mid-1900s, there was no decline for summer tourists. The automobile took over the task of ferrying vacationers to the area. As the crowds grew each year, the number that stayed behind at the end of the summer increased as well. In fact, a very large percentage of the township's population today originally came from the New York metropolitan area within one or two generations.

Today Mamakating still offers a respite for vacationers as well as its year-round residents. As time marches on, it is easy to lose track of Mamakating's humble beginnings. This book is designed to offer a glimpse into the Mamakating of yesteryear and give the reader a sense of the history of the area.

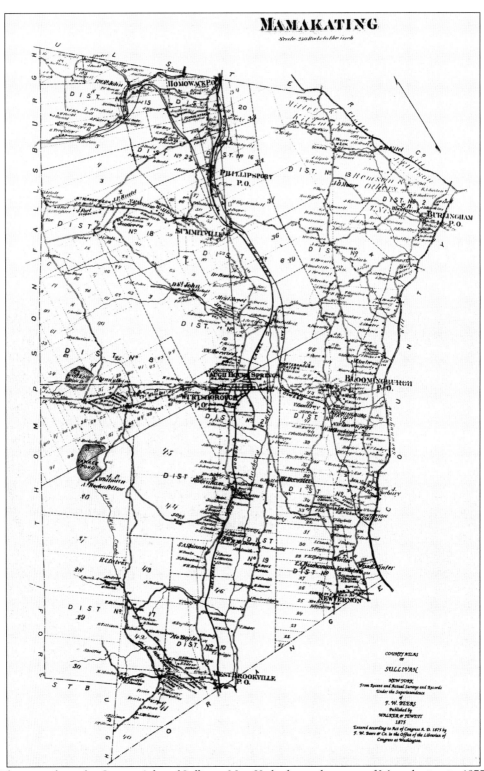

This map, from the *County Atlas of Sullivan, New York*, shows the town of Mamakating in 1875.

One
BUSINESS AND INDUSTRY

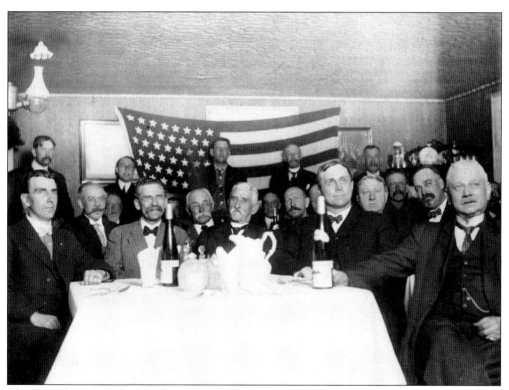

The Wurtsboro Board of Trade was organized on April 7, 1911. This photograph, from about 1916, was taken in the dining room of the Gumaer House, presently known as Danny's. Pictured from left to right are (first row, sitting) Charlie Helm, Joseph Holmes, C. G. Bennett, Dr. Merritt, and Adolph D. Ernest; (second row, sitting) Dr. Pearson, John H. Mott, Jacob Helm, William H. Delano, Thomas H. Shimer, C. D. Drew, John S. Robinson, and C. H. Puttner; (third row, standing) Leo M. Smith, Grant Van Buren, Louis A. Gumaer, Chauncey Newkirk, and Richard H. Conner. (Courtesy of Wurtsboro Fire Company No. 1.)

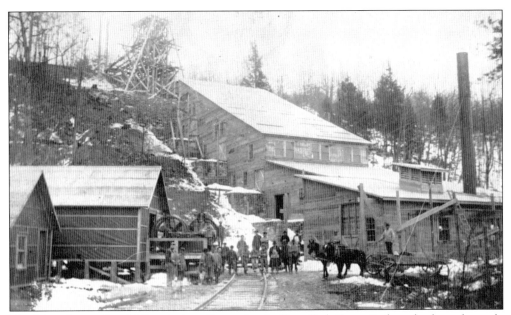

The Mamakating Lead Mine is the oldest mine in New York State. It dates back to the early 1600s. The mine is located on the western side of the Shawangunk Mountains. It contained rich deposits of zinc and lead as well as trace amounts of copper, pyrite, silver, and gold. Although the mines have been in and out of operation many times throughout the years, they never really prospered due to the difficulty in separating the metals. The last spurt of activity was in the early 1960s. Although the buildings are gone, remnants of their foundations as well as mine entrances can still be seen. (Courtesy of Kevin and Tish Moore.)

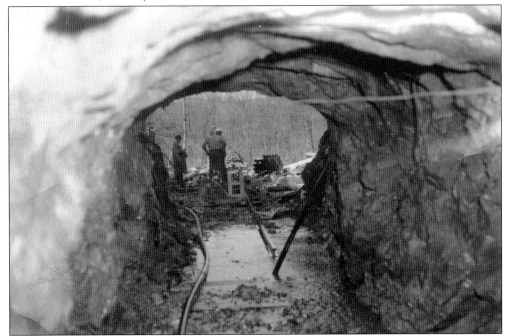

This photograph was taken inside of the Mamakating Lead Mine tunnels near the entrance. (Courtesy of Kevin and Tish Moore.)

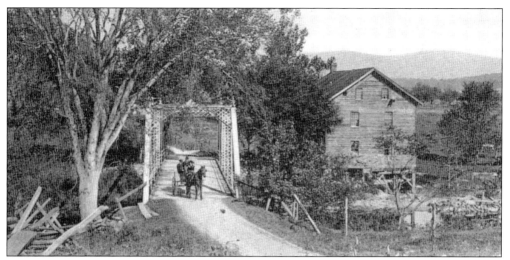

This 1907 photograph shows the iron bridge that crossed the Shawangunk Kill. The Rockwell Boardinghouse to the right was originally a gristmill. The woman in the carriage crossing the bridge is Olive (Hamilton) Sauer. (Courtesy of the McCormick and Mueller families.)

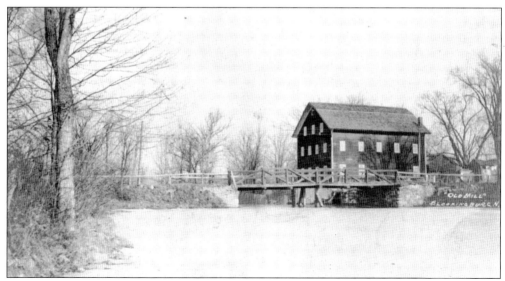

The Bloomingburg Grist Mill was built about 1832 by Virgil Duryea. When taken over by Charles W. Mance, it became known by locals as Mance's Mill. In addition to corn and buckwheat, Mance also processed wheat, rye, and oats, and it was considered one of the best mills in the area. The building was razed in the 1940s. (Courtesy of Linda J. M. Tintle.)

The Wurtsboro Steam Laundry was started in 1929 by Solomon Diamond and his son Paul. It was built on part of a 188-acre farm purchased by Solomon in 1911 when he arrived from Russia. During World War II, tractor trailers brought laundry from troop ships stationed in New York Harbor to be cleaned. In later years, other family members became involved in the business. During peak production, the laundry employed over 65 people. The business was sold in 1967, and a lumber company operated there for many years afterward. The building is located on South Road just outside the Wurtsboro village limits. (Courtesy of Arlene Diamond Borko and Deanna Mendels.)

This boardinghouse was located just to the right of the Wurtsboro Steam Laundry. During its peak production years, some of the laundry's employees were housed here. The house was burned by the Wurtsboro Fire Department as a practice drill in the late 1960s after the steam laundry was sold. All that remains today is a dilapidated outbuilding. (Courtesy of Esther D. Levine.)

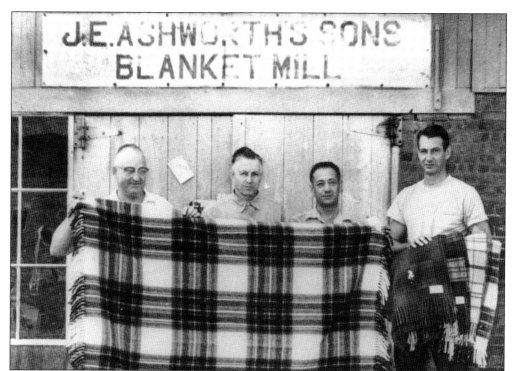

The Ashworth Blanket Mill of Westbrookville had a reputation of turning out some of the finest blankets in the country. During World War I, the mill made blankets for the army. When the advent of the automobile caused a drop in demand for horse blankets, the mill turned to bed blankets. It operated until 1961, and closed because it could not compete with foreign mills and synthetic fabrics. (Courtesy of the Mamakating Historical Society.)

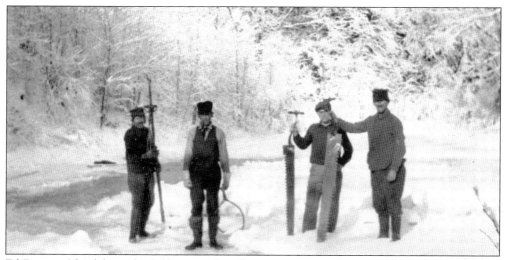

Ed Benson (third from the left) is seen here harvesting ice in the early 1900s. Benson had an icehouse on Sullivan Street in Wurtsboro where he stored ice through the summer by covering it in straw in order to prevent it from melting. (Courtesy of Katherine Startup Houston.)

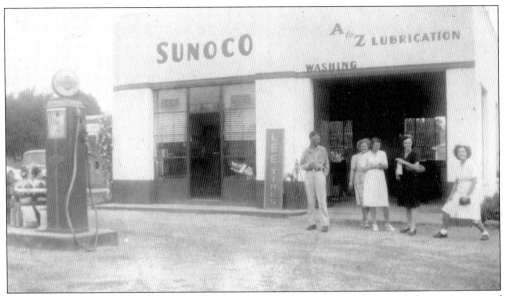

This service station was owned by Ernest "Candy" Lyons, a resident and former mayor of Wurtsboro. This building today houses Perelli's Café on the northeast corner of Berger Lane and Sullivan Street. (Courtesy of Katherine Startup Houston.)

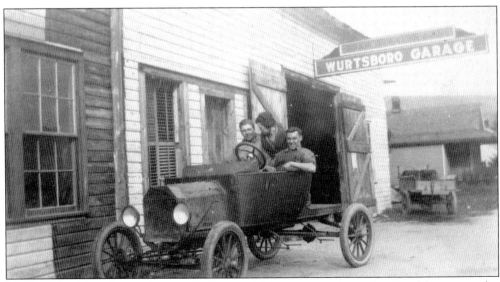

In the 1920s, Adam Startup (at the wheel) owned this service station at the site of the present-day Mamakating First Aid Squad. (Courtesy of Katherine Startup Houston.)

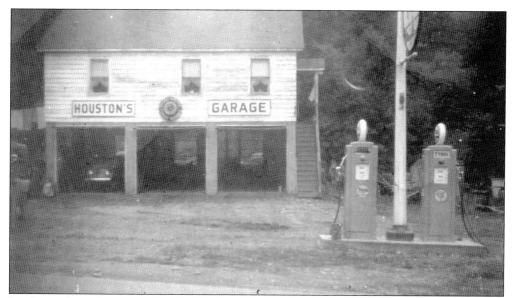

In the early 1950s, Russell Houston owned and operated this automobile repair shop on Mountain Road, near the Wurtsboro Hills entrance. Although the garage has been closed for many years and converted to living space, the Houstons still reside there. (Courtesy of Katherine Startup Houston.)

The Hurling Store was located at the corner of Hurling Road and Doolittle Road in Phillipsport. This was a popular place to stop in the 1950s for gasoline, ice cream, and candy. The store also served as a bus stop. The building still stands today, although it has been converted into a private residence. (Courtesy of Robert Rys.)

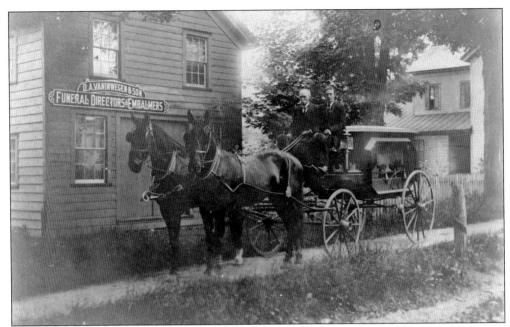

This Sullivan Street building was owned by William J. Bullard, who was the local undertaker. It was later sold to D. A. VanInwegen and Son. The first floor was used to store the hearse while the second floor was where many of the early meetings of the firemen were held. David A. VanInwegen and son Willis are seen with their hearse. This building still stands and is the home of Lynn's Flowers, which has been owned and operated by the Hairie family since 1980. (Courtesy of Wurtsboro Fire Company No. 1.)

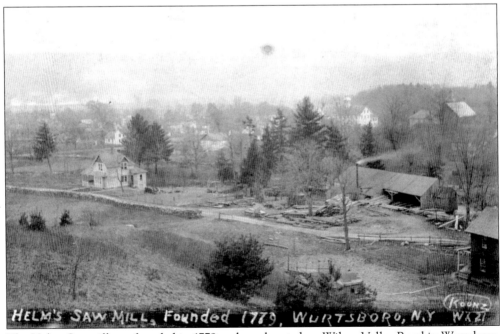

The Helms Sawmill was founded in 1779 and was located on Wilsey Valley Road in Wurtsboro. This photograph was taken in 1903. (Courtesy of Robert J. Olcott.)

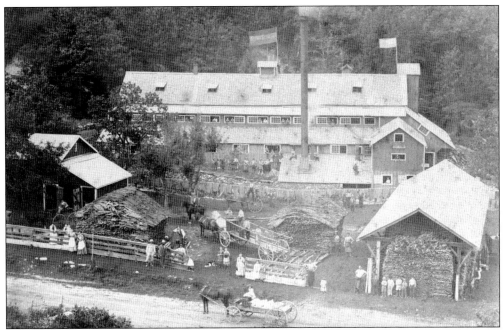

The Wurtsboro Tannery was established in 1865 by Charles Korn for the purpose of tanning upper leather and French calfskin. A labor force of 40 to 50 men tanned 75,000 skins annually. All that remains today is the foundation. The tannery was located on the northeast corner of Sullivan Street and Schultz Lane. (Courtesy of the Holmes family.)

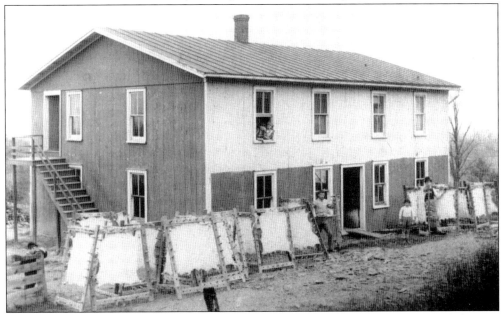

The High View Tannery was built by Joe Rogers Sr. Rogers's drum and banjo heads became famous throughout the United States. Many were made from unborn calf hides. This building was near the New York, Ontario and Western Railroad station but no longer stands today. The original tannery was located in High View on Mountain Road. This building still stands and is privately owned by Robert Cousin. (Courtesy of the Hultslander family.)

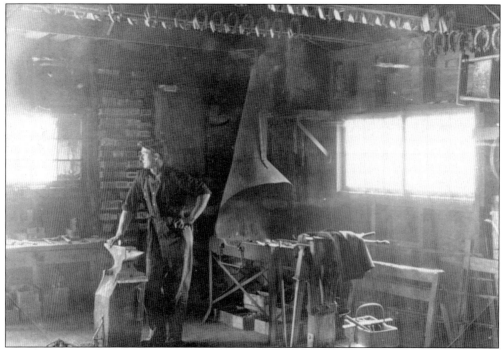

Jesse Hulse, a Bloomingburg blacksmith, takes a break from his work. (Courtesy of the Bloomingburg Restoration Foundation.)

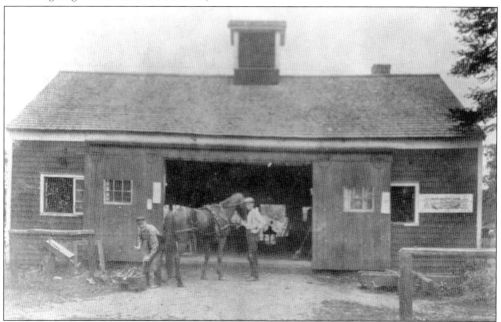

The Village blacksmith shop in Wurtsboro was operated by Joseph Rosch. He is the man seen preparing shoes for this horse. Rosch was quite busy in those days as much of his business was from travelers who came to stay in the area. The building was converted for retail use and still stands today on the south side of Sullivan Street about 50 feet east of the Route 209 intersection. (Courtesy of Wurtsboro Fire Company No. 1.)

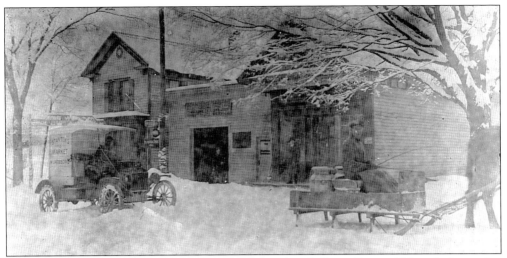

Stanton's garage and market in Wurtsboro was located on Sullivan Street. Although the market did not last long, the garage was a mainstay in the village for over 60 years. (Courtesy of the Newkirk family.)

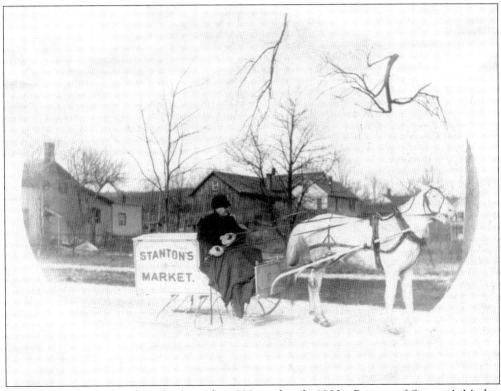

Food was often delivered by sleigh in the 1800s and early 1900s. Patrons of Stanton's Market in Wurtsboro would place their orders, and employees would make the deliveries. (Courtesy of Robert J. Olcott.)

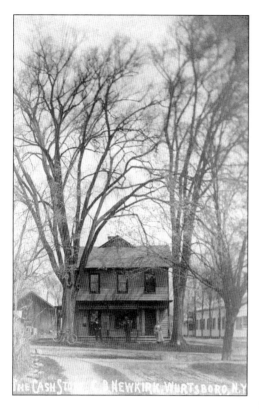

The Cash Store owned by Chauncey B. Newkirk was located on the northwest corner of Sullivan and Fourth Streets in Wurtsboro. Greenwald Law Offices have been located there for many years. The Wurtsboro schoolhouse can be seen just to the right. (Courtesy of the Newkirk family.)

This is believed to be a view of the inside of Art's Sweet Shop, owned by Art Krier. The store was located on Sullivan Street in Wurtsboro in the former Newkirk Building where the laundromat is now. (Courtesy of the Newkirk family.)

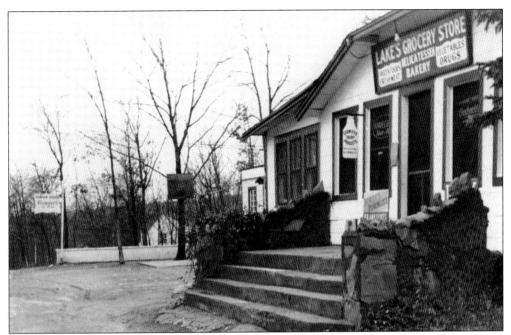

Lake's Grocery Store in Wurtsboro Hills was a popular stop for summer residents. It was the local general store where shoppers could buy sandwiches, baked goods, beverages, and staple items. Although the store closed many years ago, the building still remains and is a private residence. (Courtesy of Walt Finkle.)

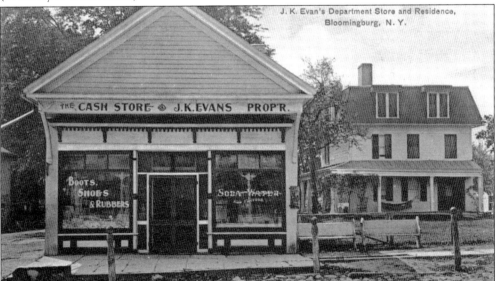

The Cash Store, owned and operated by John K. Evans, was located on the corner of Main Street and Winterton Road in Bloomingburg. Like most country stores, it carried food, clothing, hardware, and many other items. Evans was a democratic leader, and he served in the state assembly. He was also very good friends with Franklin D. Roosevelt. It was said that this friendship was influential in getting the main street built when Roosevelt was governor. Evans's home is seen to the right of his store. Both buildings were destroyed in the great fire of 1922. (Courtesy of Linda J. M. Tintle.)

Marchant's store, located on the northeast corner of Sullivan and Second Streets was originally owned by J. V. Doss and later the Masten family. Lewis and Kathryn Marchant owned the store until 1973. For many years, the store operated as an ice-cream parlor, soda fountain, and candy store. It was known as the Landmark when it succumbed to fire in the early 1980s. The post office is seen to the left. (Courtesy of Lewis W. Marchant.)

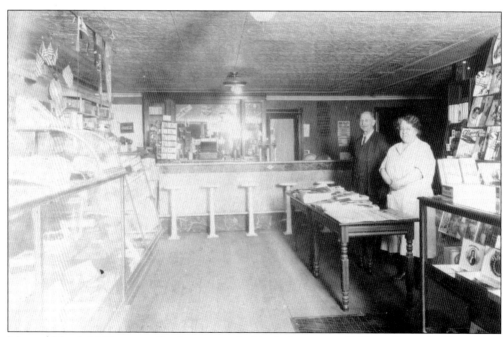

Mr. and Mrs. J. V. Doss pose for the camera inside their store on Sullivan Street in Wurtsboro. (Courtesy of Robert J. Olcott.)

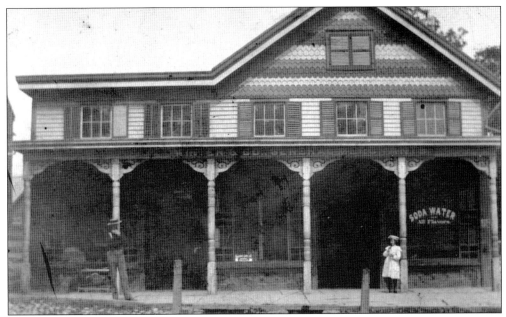

The Winter Family Store, pictured here in 1870, was later purchased by DuBois F. Collins and was known as Collins' Store for many years. The store was located on the corner of Main and North Streets in Bloomingburg. In addition to groceries and hardware, it also carried tinware, crockery, horse blankets, clothing, and shoes. This building burned to the ground in the great fire of 1922. (Courtesy of the Bloomingburg Restoration Foundation.)

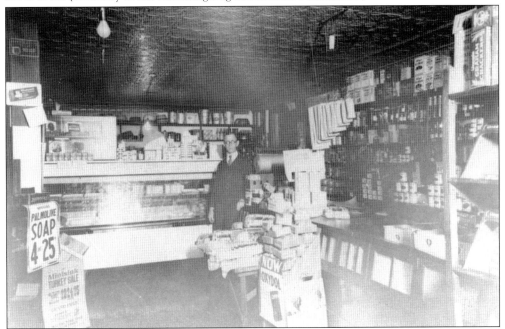

DuBois F. Collins poses in his store shortly before it was destroyed by fire. In the summer, he would personally visit the local boardinghouses once a week to take their grocery orders. The next day, another man would deliver the requested items via horse and wagon. (Courtesy of the Bloomingburg Restoration Foundation.)

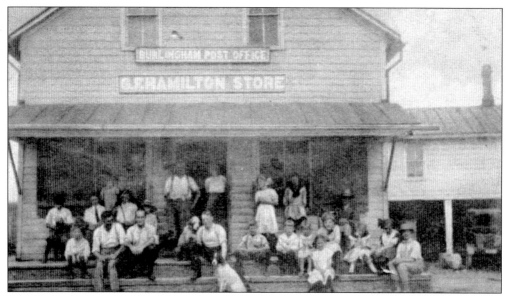

The George F. Hamilton Store located in Burlingham was built in 1810 and was once owned by Daniel Bull. The town hall was located to the right just above the garage. The store and garage are still standing, and the store is still in operation. (Courtesy of the Mamakating Historical Society.)

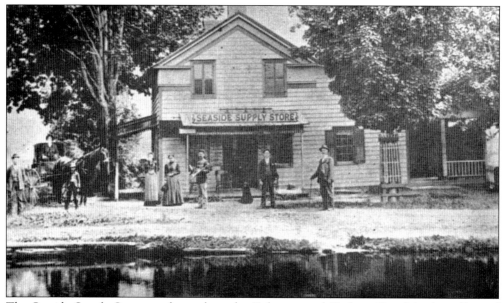

The Seaside Supply Store was located on the Delaware and Hudson Canal in the village of Wurtsboro. Many canal visitors and residents would shop here during the canal days. The structure still stands today. (Courtesy of Patricia Moore.)

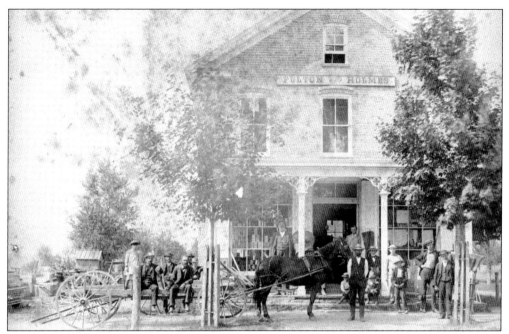

With the exception of 18 years, the Fulton and Holmes Store has been in continuous operation in Wurtsboro since 1838 when it was first opened by H. R. Morris to supply the nearby Delaware and Hudson Canal. The store was purchased by James Fulton and Joseph Holmes in 1870 and is still operating today by fourth-generation members of the Holmes family as a historic store and tourist attraction. It is known as Canal Towne Emporium today. (Courtesy of the Holmes family.)

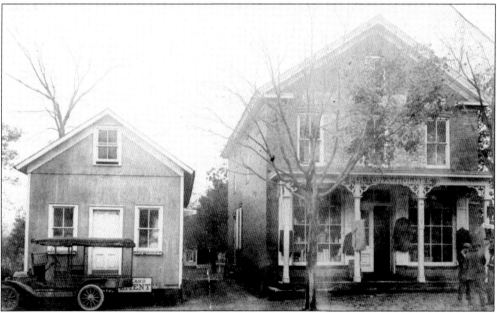

This 1901 photograph shows the Fulton and Holmes Store on the corner of Sullivan and Hudson Streets in Wurtsboro. The building to the left was for leather storage. The two buildings were joined together in 1932 to form a larger store to better serve the community. (Courtesy of the Holmes family.)

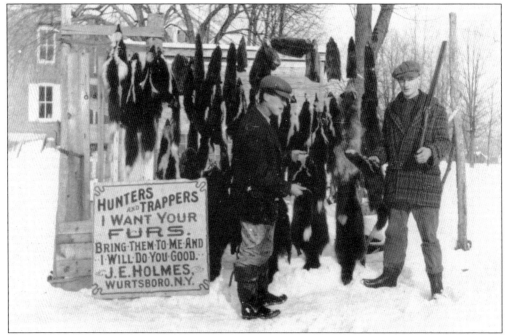

Lyman A. Holmes operates a fur-trading stand in front of Fulton and Holmes in Wurtsboro. This sign is currently on display in the store, which is still operated by the Holmes family. (Courtesy of the Holmes family.)

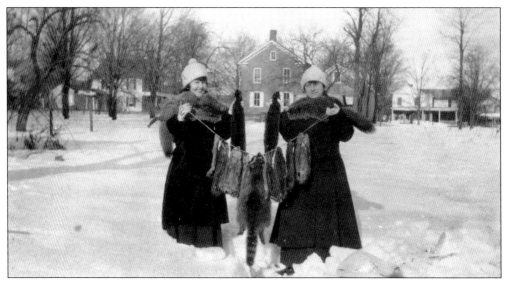

Ethel (Wolf) Holmes, wife of Lyman O. Holmes, and her friend Emily (Bornemann) Startup display fur pelts to be sold at family's store in the background. (Courtesy of Katherine Startup Houston.)

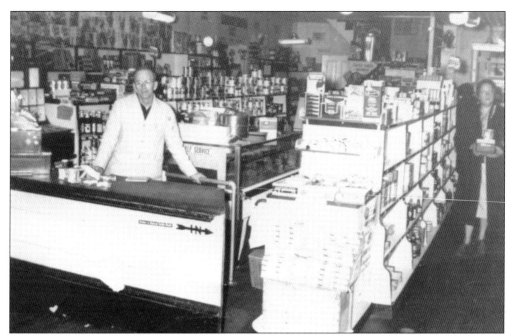

This is a later interior photograph of the Fulton and Holmes Store. Head clerk George R. Olcott would greet patrons from 1910 to 1958. The worn spot on the floor where he stood behind the counter all those years is still visible today and is known as "George's hole." (Courtesy of the Holmes family.)

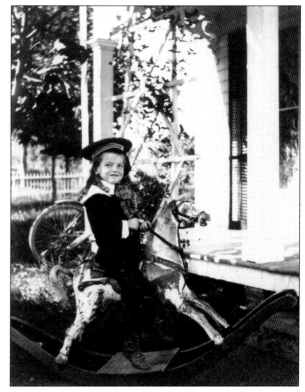

Lyman R. Holmes rides his rocking horse in 1896. The rocking horse has become the Canal Towne logo and is on display on the second floor of the store. (Courtesy of the Holmes family.)

Fred's Restaurant was located on the northern side of Sullivan Street. In later years, it was known as the Happy Vineyard. Most recently, it was the Kowloon Chinese Restaurant, but it has been vacant for a few years. (Courtesy of Walt Finkle.)

The Old Valley Restaurant, pictured here in the 1970s, was a popular place to eat in Wurtsboro for many years. It was owned and operated by the Schnitzer family. The front portion of the building was a luncheonette that was open for breakfast and lunch, and the restaurant in the rear served delicious Italian and German meals for dinner. In the early part of the century, the building was the location of Robinson's Bowling Alley. (Courtesy of the Schnitzer family.)

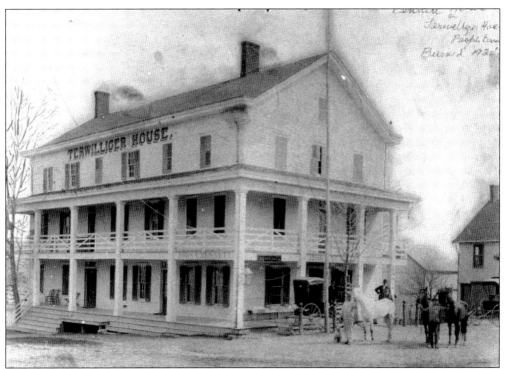

The Terwilliger House, also known as Bennett's Hotel, was owned by John F. Bennett and his son. It was considered the center of community entertainment as it had both outside and inside dance halls as well as a large livery. The hotel was located on the corner of Main Street and Winterton Road. It burned in the great Bloomingburg fire of 1922. This photograph was taken in 1891. (Courtesy of the Bloomingburg Restoration Foundation.)

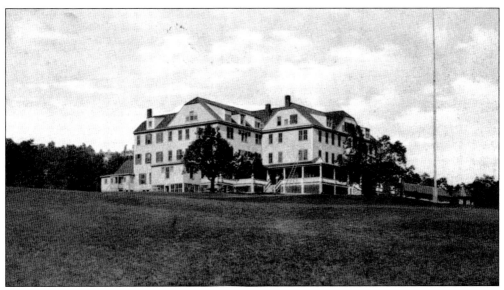

The Shawanga Lodge Hotel was, for many years, the showplace of the area. This was the original hotel that burned in the 1920s. It was replaced by a new building that also suffered the same fate when fire engulfed it in 1973. (Courtesy of the Bloomingburg Restoration Foundation.)

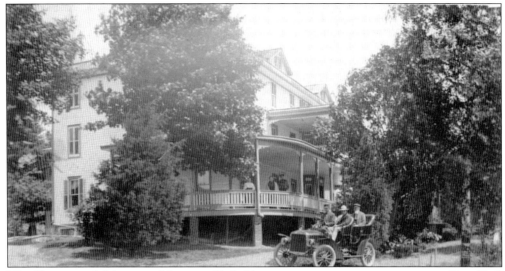

The Shawangunk Mountain House in High View was a summer resort catering to New York City residents. This summer resort boasted a "cool and invigorating atmosphere laden with health giving ozone" and an absence of swamps and malaria. The railroad station, post office, and telegraph were all a short walk from the property. (Courtesy of the Hultslander family.)

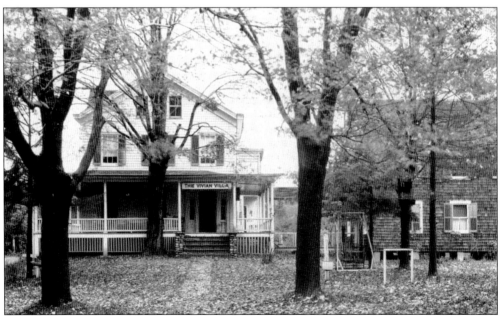

The Vivian Villa was a boardinghouse owned and operated by Mr. and Mrs. Beakes. They usually only took in boarders during the summer months. The home is located on Burlingham Road in Bloomingburg. (Courtesy of the Bloomingburg Restoration Foundation.)

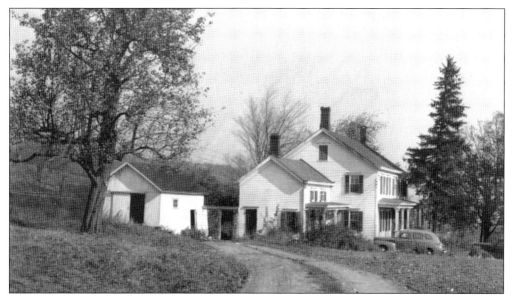

This mountainside farm in High View was purchased by Eli Hultslander in 1865. Vacationers rented rooms for $16 a week and were provided with eggs, milk, poultry, and vegetables all produced on site. Although no longer a boardinghouse, the farm still remains in the Hultslander family. (Courtesy of the Hultslander family.)

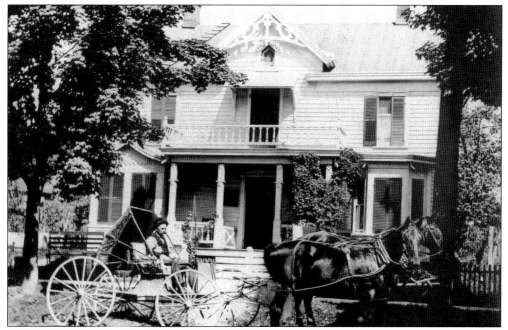

This home, located on Main Street in Bloomingburg, was thought to be VanInwegen's Funeral Home for a short while. After years of neglect, the home was beautifully restored by its present owner. (Courtesy of VanInwegen-Kenny.)

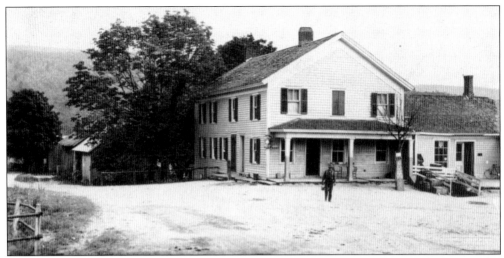

This is an early view of the Westbrookville post office and general store, which was also Hotel Rhodes, later known as Ye Olde Tavern. The structure no longer stands. (Courtesy of Linda J. M. Tintle.)

The Blue Paradise Rooming House was located along Sullivan Street on the westernmost edge of the village of Wurtsboro. The complex consisted of three buildings, a stone fountain, and an inground pool. It was inhabited until the 1980s, when the buildings fell into disrepair. The property was eventually purchased by the village, and the structures were razed. It is now the site of a senior living complex. (Courtesy of Katherine Startup Houston.)

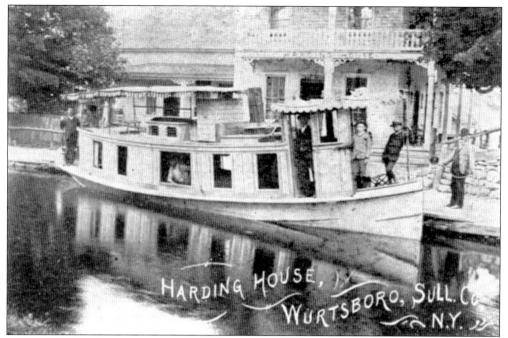

The famous Harding House stood on the north side of Sullivan Street on the towpath of the Delaware and Hudson Canal in Wurtsboro. This landmark was a favorite stopping place for canal visitors in the 1800s. (Author's collection.)

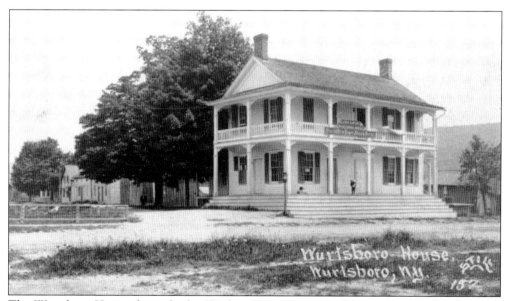

The Wurtsboro House, formerly the Harding House, continued to operate as a hotel until it burned on March 31, 1909. It was rebuilt by the Jacob family, which continued to operate a hotel on that site. In 1967, the building was razed due to disrepair. Later the meeting room of the Mamakating First Aid Squad building was added on after the hotel was razed. (Courtesy of the Lindsay-Dunn collection.)

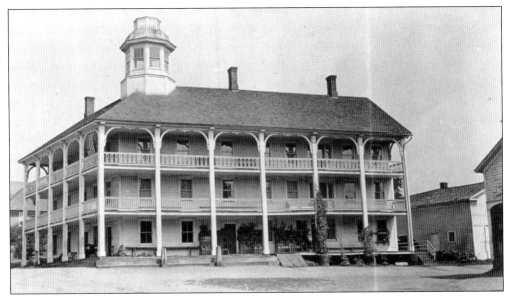

Situated on the northwest corner of Route 209 and Sullivan Street, the Olcott House was built in 1843 by George H. Olcott. It contained 50 rooms, a general store, saloon, carriage house, and livery. The hotel was famous for a museum on the third floor that contained relics of all sorts. Another curiosity was a glass tank in the barroom that contained several poisonous rattlesnakes. In 1920, the hotel was sold to Jack Butler, who operated it as the Butler House. On March 8, 1923, the hotel suffered a fatal fire and the entire building burned to the ground. (Courtesy of the Mamakating Historical Society.)

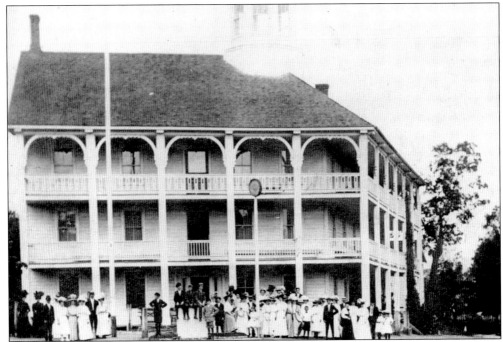

This photograph is another view of the Olcott House captured by local photographer E. A. Koonz. (Courtesy of Wurtsboro Fire Company No. 1.)

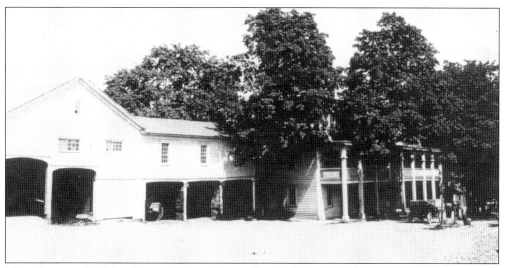

This photograph of the Gumaer House (presently called Danny's) shows the livery when it was still part of the hotel that was built in 1814. The livery occupied most of the area where the parking lot is located today. The west wall was actually on the edge of present-day Route 209 and just a stone's throw away from the Olcott House in Wurtsboro. (Courtesy of Linda J. M. Tintle.)

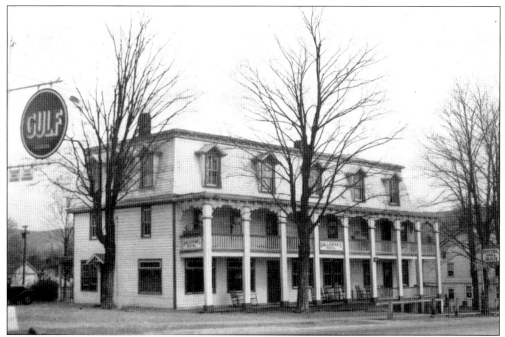

In later years, the livery was torn down, as there was a growing need for automobile parking space. This scene shows the hotel under the ownership of the Halloran family. The current owners are descendants from that family. (Courtesy of Kevin and Tish Moore.)

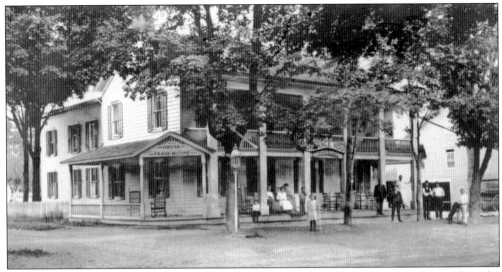

Frank McCune's Dorrance House was another prominent hotel in Wurtsboro. Situated on the corner of First and Sullivan Streets, it featured regular stage pickup and delivery of guests from the local train station, a livery, and an inviting front porch. The Dorrance House was also very popular with sportsmen as it often served the catch of the day from local lakes. The building still stands and still operates as a tavern. (Courtesy of Wurtsboro Fire Company No. 1.)

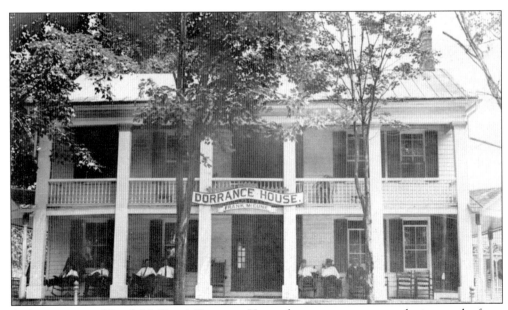

A close-up view of Frank McCune's Dorrance House shows summer guests relaxing on the front porch. (Courtesy of the Mamakating Historical Society.)

Two

HOMES AND STREET SCENES

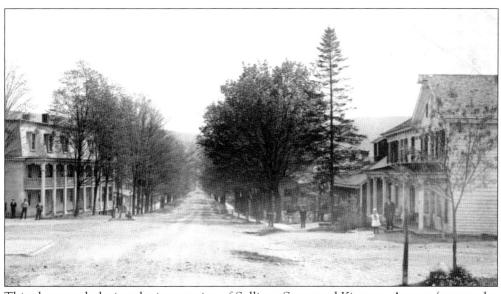

This photograph depicts the intersection of Sullivan Street and Kingston Avenue (present-day Route 209). The building on the right was originally owned by Anna Kane, who rented it to several people over the years to operate as a general store. She eventually sold it to Nathan and Fannie Marcus in 1920. In 1932, the building caught fire. It was such a stubborn blaze that the fire department telephoned the Monticello Fire Department for assistance. Assistance was rendered by Monticello, and a bill was presented to the fire department for $50 for their services. (Courtesy of Wurtsboro Fire Company No. 1.)

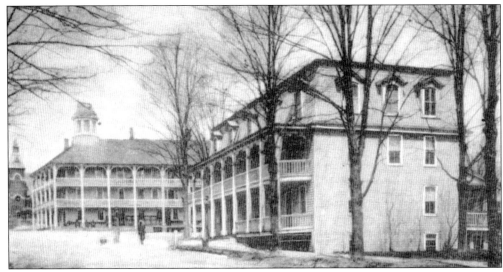

Looking west, this rare photograph shows the Gumaer House (foreground), the Olcott House, and St. Joseph's Catholic Church in Wurtsboro. (Courtesy of Linda J. M. Tintle.)

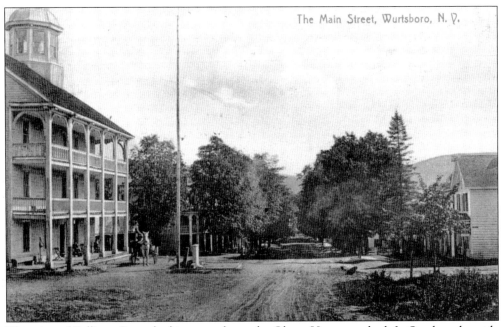

This view of Sullivan Street looking east shows the Olcott House on the left. On the other side of Kingston Avenue (present-day Route 209), the porch of the Gumaer House is visible. The building on the right was owned by Anna Kane and operated as a general store until about 1920, when Nathan and Fannie Marcus purchased it. Notice the beautiful tree-lined Sullivan Street. (Courtesy of Linda J. M. Tintle.)

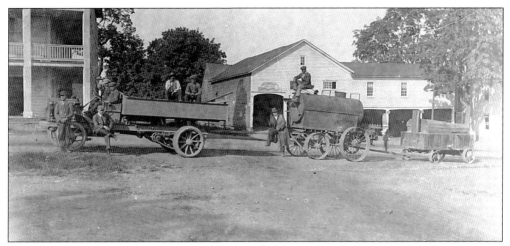

Local residents pose with their equipment on Sullivan Street at the intersection of Route 209 in this photograph from around 1900. Notice how narrow Route 209 was as it passed between the Olcott House (left) and the Gumaer House livery. (Courtesy of the Newkirk family.)

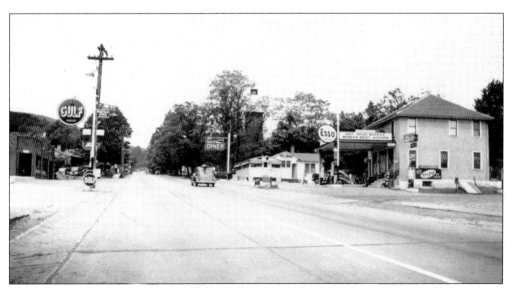

This view shows the intersection of Sullivan Street and Route 209 long before a traffic signal was installed. The brick building on the left was Smithem's Ford garage. The Esso station and Sol's Diner are no longer standing. The Gulf station, although not visible except for the sign, is still standing today, along with the old signpost. (Courtesy of Robert J. Olcott.)

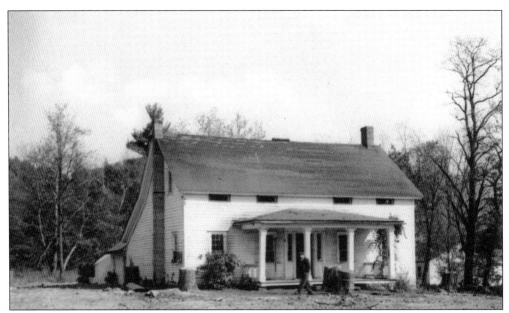

Although there is no trace of this home today, it was located behind the St. Joseph's Church hall in Wurtsboro. The newly constructed hall was built to accommodate the additional worshippers who arrived each summer. Due to a need for more parking space, this building was burned by the Wurtsboro Fire Department in 1960 to make way for a larger lot. At that time, the home was estimated to be around 120 years old. (Courtesy of Wurtsboro Fire Company No. 1.)

These two homes once stood alongside present-day Route 209 in Wurtsboro where the Stewart's shop and the Wurtsboro Plaza are located today. The home on the right was owned by Mame (McDonald) Moore. Note the sign for Halloran's Hotel on the left. (Courtesy of Kevin and Tish Moore.)

This photograph depicts the northern side of Sullivan Street. The Rosemont House is on the far right. Just next door, busses picked up and dropped off visitors to and from many places. The house on the left is where John Masten lived and operated his barbershop for many years. The barbershop is still in operation today. (Courtesy of the Schnitzer family.)

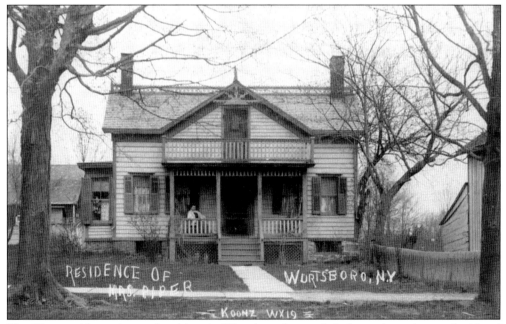

The Piper residence is another historic Wurtsboro home. It is located on the north side of Sullivan Street, just west of Fourth Street. This home and its famous neighbor to the west, the Rosemont House, can still be seen today. (Courtesy of Jack and Toni Haley.)

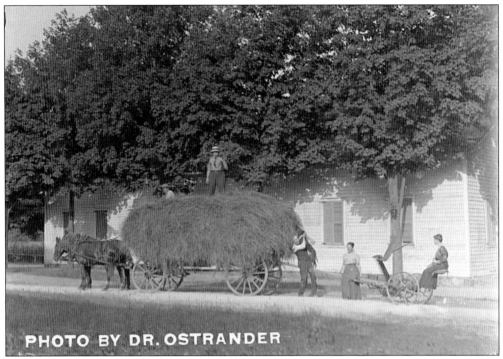

This group of farmers proudly displays their wagonload of fresh-cut hay on Fourth Street in Wurtsboro. The schoolhouse can be seen in the background. (Courtesy of the Newkirk family.)

This Sullivan Street home in Wurtsboro is located adjacent to the Veteran's Memorial Park. Like many early homes in the area, this had a front porch that is no longer attached to the building today. (Courtesy of the Masten family.)

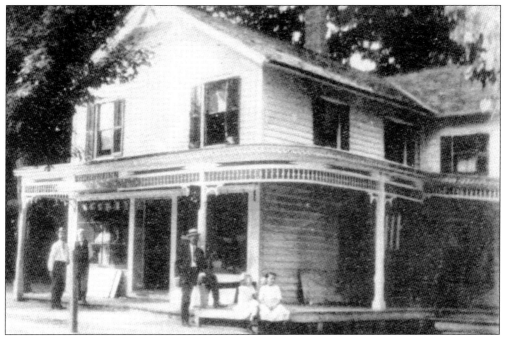

This building is located on the northeast corner of Sullivan and Third Streets in Wurtsboro. It served as a post office in those days but has been the home of many businesses since then. This is how the building appeared in 1919. (Courtesy of Linda J. M. Tintle.)

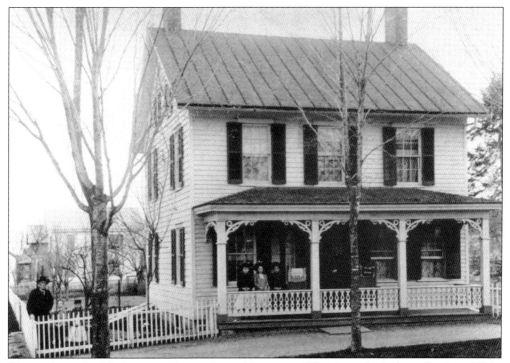

This is how the VanInwegen-Kenny funeral home in Wurtsboro looked in the late 1800s. (Courtesy of VanInwegen-Kenny.)

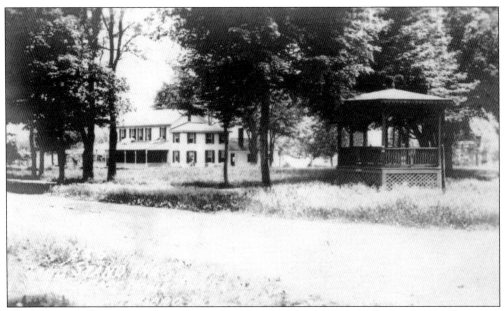

The Dorrance House Annex is seen in this photograph along with the bandstand that once stood where Michael Diamond Square is now located in Wurtsboro. (Courtesy of Jack and Toni Haley.)

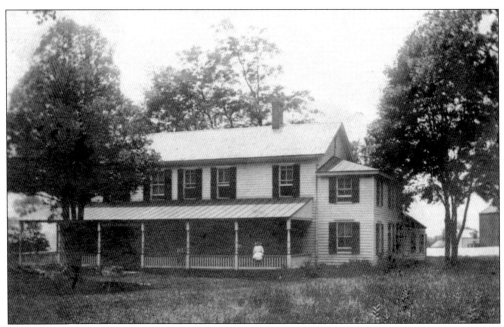

This house was located across the street from Frank McCune's Dorrance House, most recently known as the Wurtsboro Hotel. It was referred to as the Dorrance House Annex. It also once served as a New York State Police barracks. The home is still standing and has been owned for many years by the Wilensky family. (Courtesy of the Lindsay-Dunn collection.)

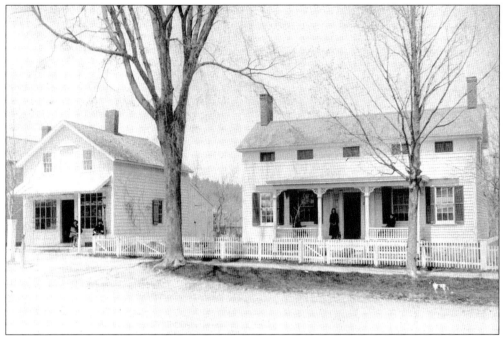

In 1873, the building to the left served as the Wurtsboro Post Office. It is no longer in existence. The home on the right was the Roosa homestead and was owned by Harry and Alice Roosa. Harry was a mason, and he eventually built a beautiful stone porch in front of the home. The house has been the home of many businesses in recent years, including a tattoo parlor and various offices. This building is located on the north side of Sullivan Street between First and Second Streets. (Courtesy of Mardell Auer.)

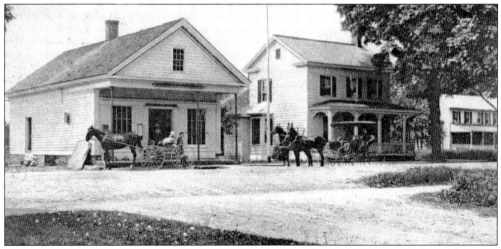

The old post office in Wurtsboro is seen in this photograph on the left. It was located on the south side of Sullivan Street, opposite the entrance to Canal Street. Mercein Skinner, a former mayor of the village, also operated a dry goods store in this building. The building still stands today, most recently occupied as a hardware store, but it is now vacant. The building in the middle has been occupied by Hamill's Antiques for many years, and the building on the right was once the annex for the Dorrance House and is now a private residence. (Courtesy of the Mamakating Historical Society.)

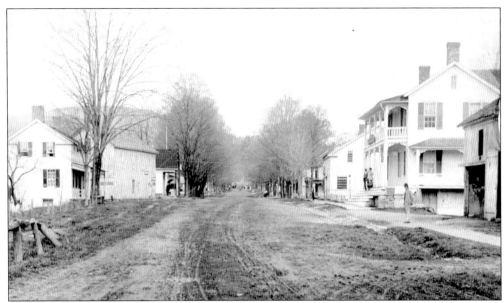

This view looks west on Sullivan Street near Berger Lane in Wurtsboro in the late 1800s. (Courtesy of the Lindsay-Dunn collection.)

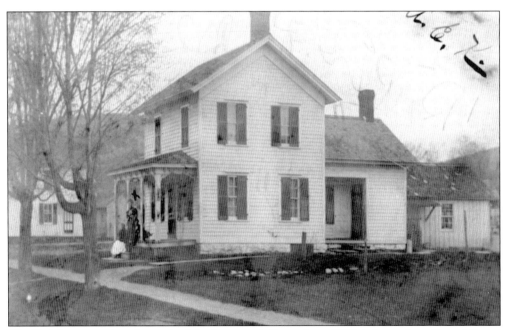

The Kirk homestead as shown in this photograph from about 1908 is located on Grand Street in Wurtsboro. It is presently owned by Dr. Robert and Lisa Justus. The Moore family residence is seen just to the left. (Courtesy of Robert and Lisa Justus.)

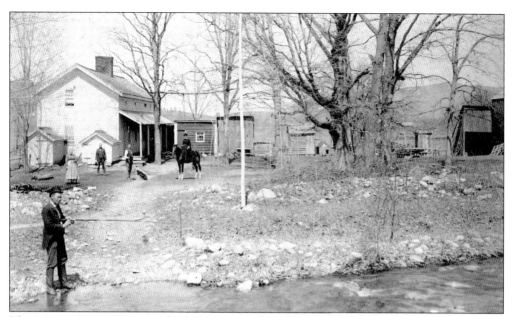

The Masten-Quinn House is the first home in the village of Wurtsboro to be registered on the National Register of Historic Places. It was built around 1832 by Lawrence Masten, grandson of Johannes Masten. Johannes was the original purchaser of the 1,000 acres of the Minisink Patent, which comprises most of modern-day Wurtsboro. The house was part of a 100-acre dairy farm believed to be one of the earliest in the village. The house and farm changed hands several times and are currently owned by Michael and Monika Roosa. (Author's collection.)

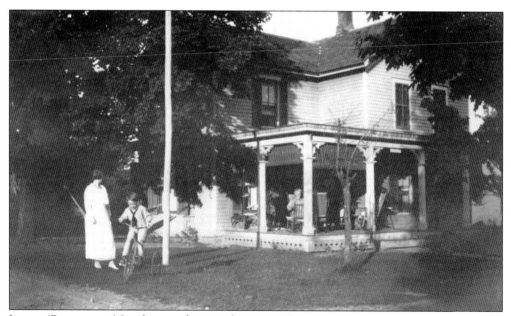

Louise (Bornemann) Jacobus watches over her son Walter Jacobus as Augusta Bornemann looks on from the porch. This home still stands today and is located on the northeast corner of Pine and Third Streets in Wurtsboro. It may look a little different today because the porch was eventually enclosed. (Courtesy of Katherine Startup Houston.)

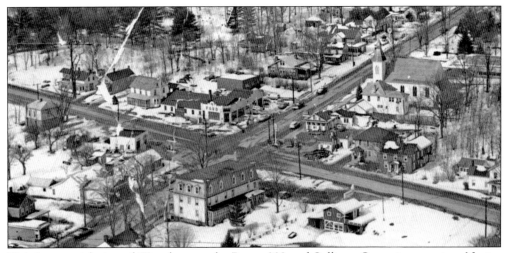

This is an aerial view of Wurtsboro at the Route 209 and Sullivan Street intersection. Notice the Ford dealership on the southwest corner and the homes that, at one time, existed on the western side of Route 209 just north of the intersection. (Courtesy of Jack and Toni Haley.)

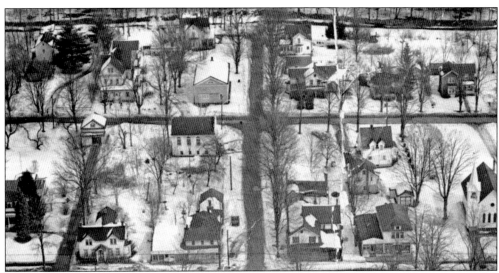

This is another interesting aerial view of Wurtsboro that shows the intersection of Third Street (running top to bottom) and Pine Street. Note the building still standing in the place where Veteran's Memorial Park is now. The original Methodist church on the corner of Pine and Third Streets was also still standing at the time. (Courtesy of Jack and Toni Haley.)

Wurtsboro Hills was best known for its summer homes and hunting cabins. This was the entrance to Camp Eltrym in 1927. It was a summer home frequented by Vivian (Treyz) Cohan. Like so many others in Wurtsboro Hills, this home has been converted to a year-round residence and still stands on the corner of Trail Two and Dogwood Trail. (Courtesy of Vivian Cohan.)

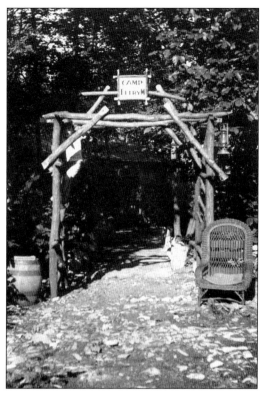

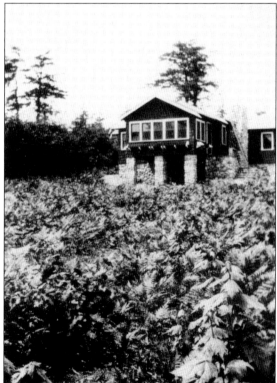

This summer home was originally built in 1929 by Raymonde Mingot. This was a typical summer home in Wurtsboro Hills for that time period. In later years, the home underwent many changes, including the addition of a formal dining room and many fieldstone walls around the property. It is best remembered today as LaMingotiere. Although it changed hands to the Schenker family, it remained a popular upscale French restaurant until its closing in the early 1990s. (Courtesy of Andre and Yvonne Caradec.)

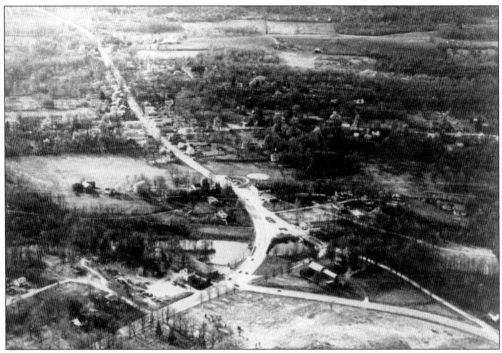
This aerial view of Bloomingburg was taken from Orange County looking west. (Courtesy of the Bloomingburg Fire Company.)

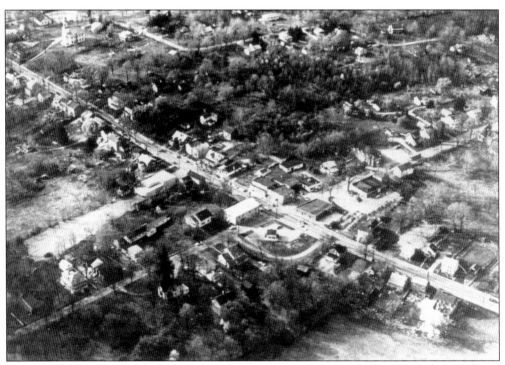
This aerial photograph of Bloomingburg shows a large portion of the center of the village. (Courtesy of the Bloomingburg Fire Company.)

The Rose Villa was owned by the Clapham family in Bloomingburg. It was considered to be one of the nicest homes in the area, with its stained-glass windows in the doors and beautiful barn. The barn was later converted into a home that still stands; however, the original home no longer exists. (Courtesy of the Bloomingburg Restoration Foundation.)

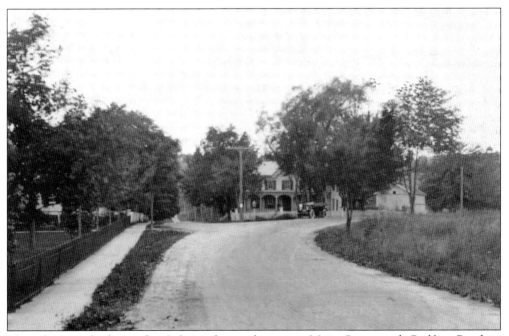

This photograph shows the fork in the road at west Main Street and Godfrey Road in Bloomingburg. At the time this photograph was taken, Godfrey Road was the primary route into the village from the west. The house in the center was built in the 1800s and is still in existence today. (Courtesy of Loretta Franklin.)

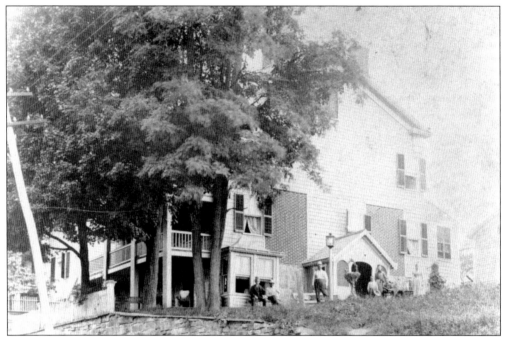

This home, located on Main Street in Bloomingburg, was built by Dr. Murray Seagers and is currently owned by the Potts family. Seagers was the doctor for the local railroad employees. (Courtesy of the Bloomingburg Restoration Foundation.)

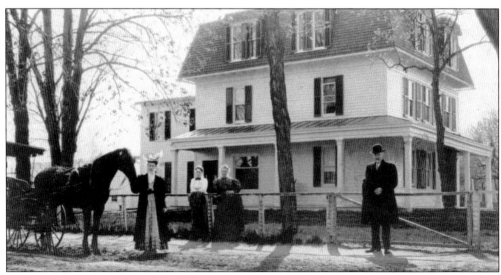

John K. Evans (right) poses in front of his home on Main Street in Bloomingburg. His home, as well as his business next door, was burnt in the great fire of 1922. (Courtesy of the Lindsay-Dunn collection.)

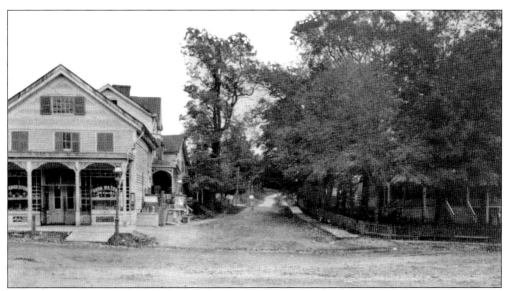

This is a view of North Road from the square in Bloomingburg. This photograph was taken well before the great fire of 1922. Collins store is the building to the left. It is interesting to note that North Road was just a narrow dirt path at one time. (Courtesy of the Hultslander family.)

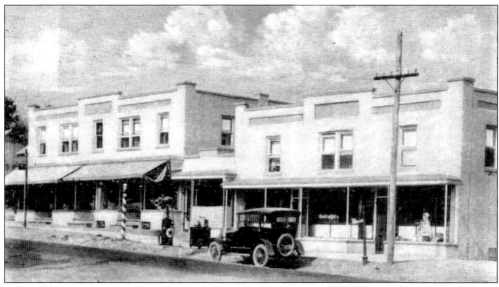

After the great fire of 1922 in Bloomingburg, D. F. Collins replaced his building with this one that looks very much the same today. At the time this photograph was taken, the building contained a bowling alley, an ice-cream shop, a barber, and a meat market. (Courtesy of Linda J. M. Tintle.)

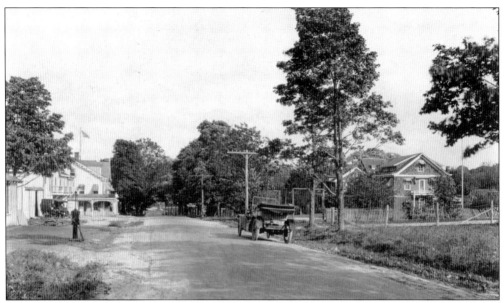

This view of Main Street in Bloomingburg is looking east toward Middletown. It is interesting to note that this section of road now looks nothing like it did when this photograph was taken. (Courtesy of Loretta Franklin.)

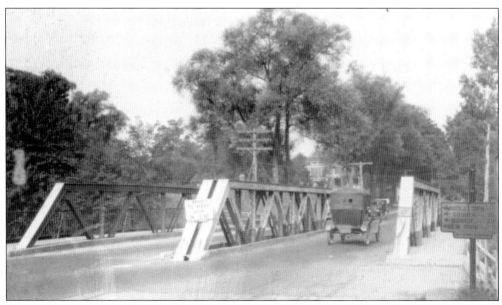

The two-lane bridge in Bloomingburg that connected Orange and Sullivan Counties is pictured here in July 1928. (Courtesy of the Hultslander family.)

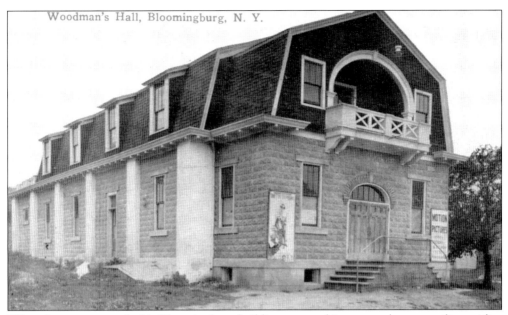

When first constructed, this Bloomingburg building was nothing more than a pavilion with a partial basement. In 1910, the Modern Woodmen of America began to hold dances and various fund-raisers in order to enclose the structure that would later become their meeting place. Many community events, such as auctions, plays, and fairs, were held there over the years. The building was later renamed Memorial Hall in honor of the local soldiers who served during World War I. (Courtesy of the Hultslander family.)

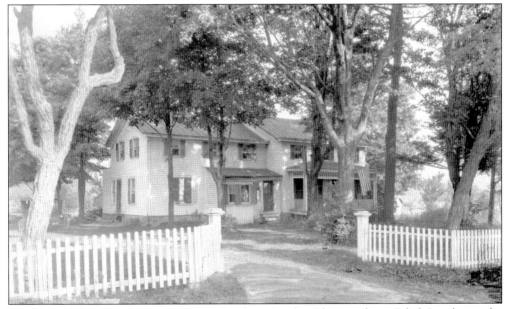

The Gowdy Homestead is situated on Burlingham Road in Bloomingburg. Ethel Gowdy was the last-known Gowdy family member to occupy this home. Gowdy served as the postmistress in Bloomingburg from 1960 to 1974. (Courtesy of the Bloomingburg Restoration Foundation.)

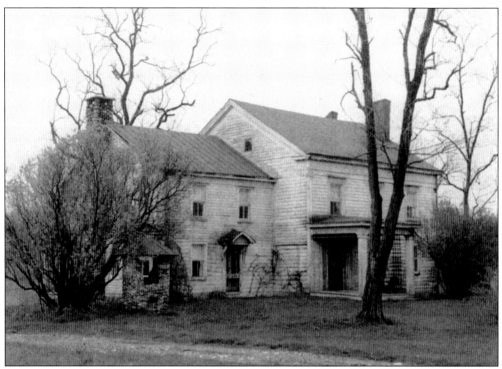

Austin Blair Anderson's home, called Holmcroft, was a boardinghouse in the 1940s. The home is located on Burlingham Road in Burlingham and is presently owned by Werner and Monica Mueller. (Courtesy of Werner and Monica Mueller.)

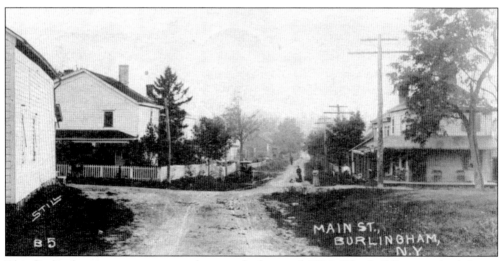

This Burlingham street scene was photographed around 1906. The building on the left was once owned by Daniel and Rebecca Bull. The building on the right was J. J. Decker's Hotel. The Burlingham post office now sits on this corner. (Courtesy of the Hultslander family.)

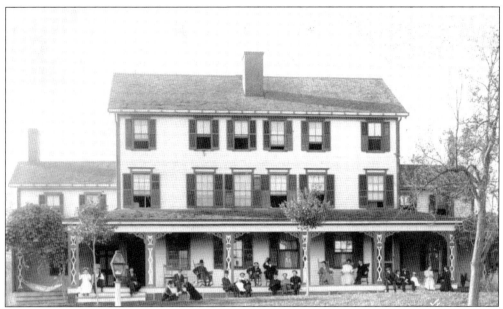

Todd's Inn, owned by Benjamin Todd, was a popular summer hotel in Burlingham. The inn was purchased from the Dietz family, which was the original owner. In the early 1900s, R. H. Macy and Company purchased the house and the land and used it as a vacation place for its employees in the summer and as a convalescent home in the winter. It was named it Camp Isida, after Isadore and Ida Straus, who had perished in the sinking of the RMS *Titanic*. Sometime after World War II, it was sold to the New York State Diabetic Association and was used as a summer camp for diabetic children. The property has changed hands a few times since then. The home still stands, but the camp has not been in use recently. (Courtesy of the Linday-Dunn collection.)

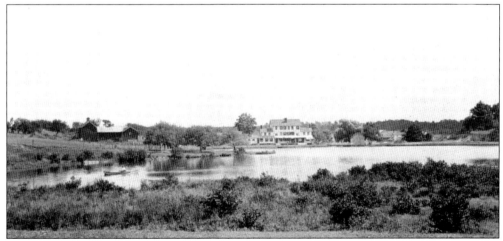

This is another view of Todd's Inn with the beautiful Macy's Lake in the foreground. (Courtesy of the Hultslander family.)

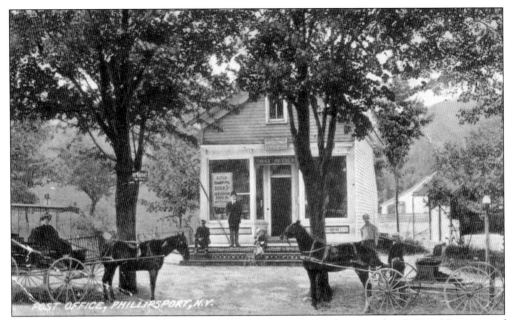
The post office and general store in Phillipsport are shown here in the 1800s. (Courtesy of Linda J. M. Tintle.)

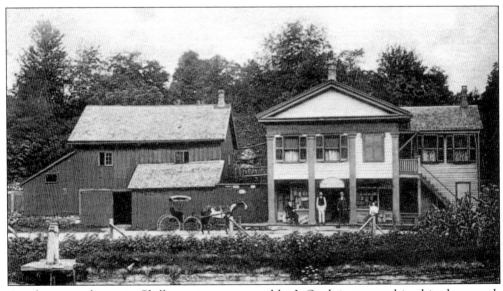
Another general store in Phillipsport, once owned by J. Opel, is captured in this photograph dating from the late 1800s. (Courtesy of the Masten family.)

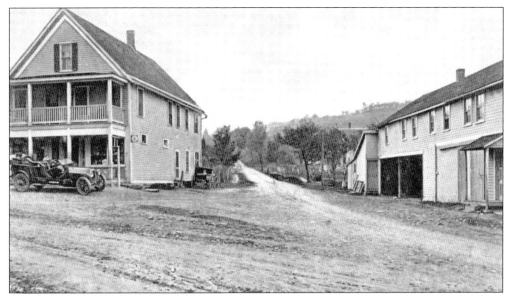

This 1930s view of Kuykendall's Corner in Summitville shows Mount Vernon Road extending into the distance. The building on the right stands vacant today. (Courtesy of the Masten family.)

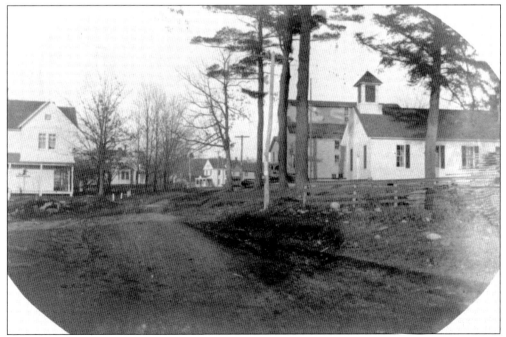

A late-1800s street scene in Summitville is captured in this vintage photograph. The schoolhouse on the right is the present-day home of the Mamakating Historical Society. (Courtesy of Linda J. M. Tintle.)

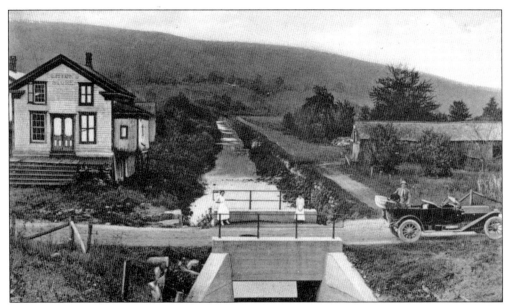

This photograph shows the Delaware and Hudson Canal looking west in Summitville. (Courtesy of Kevin and Tish Moore.)

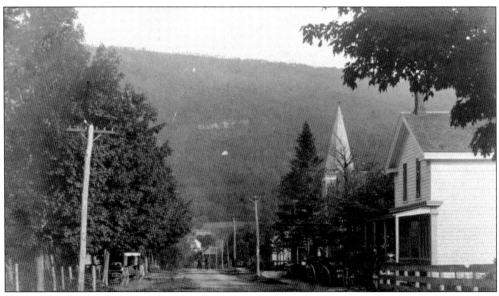

This photograph depicts an early street scene in Spring Glen on the northern edge of Mamakating. (Courtesy of the Lindsay-Dunn collection.)

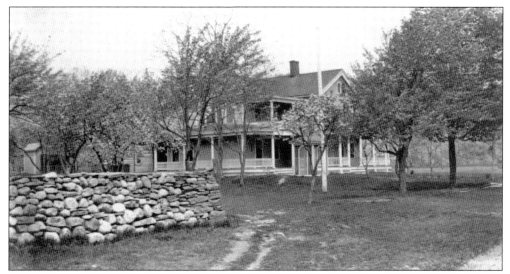
The grand Belle Terre, meaning "beautiful earth," is seen in this vintage photograph. The home still stands along Route 209 in Westbrookville. (Courtesy of Linda J. M. Tintle.)

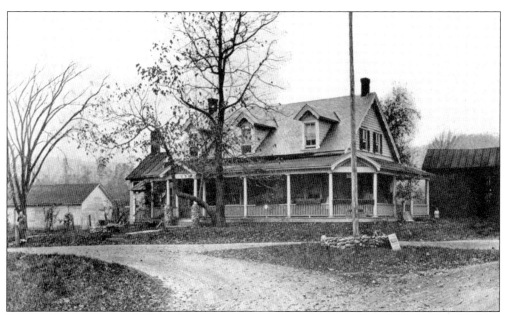
During the early- to mid-1700s, the construction of forts all along the Old Mine Road (Route 209) was necessary to protect settlers from hostile Native Americans. This is an early view of Fort Westbrook, which was built in 1752 on what is now the Sullivan County and Orange County border in Westbrookville. (Courtesy of Linda J. M. Tintle.)

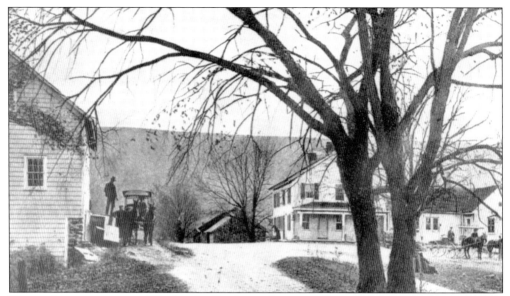

This early street scene in Westbrookville shows the post office and general store on the left, which is now a private residence. The building on the right is Hotel Rhodes, which no longer stands today. (Courtesy of Elizabeth Laden.)

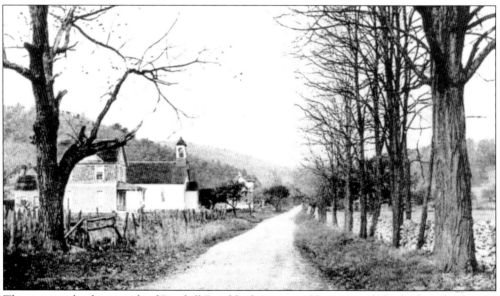

This is an early photograph of Pinekill Road looking west. (Courtesy of Elizabeth Laden.)

Three
COMMUNITY SERVICES

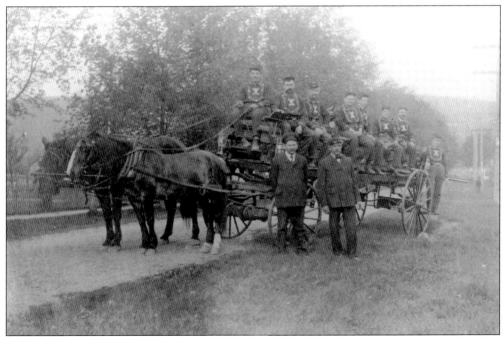

The first fire department in Mamakating was organized in Wurtsboro on October 20, 1898. This photograph depicts the Wurtsboro Hose Company in 1905. Chief Leo Smith and Assistant Chief Daniel Woods are standing in front of the company's horse-drawn hose cart. (Courtesy of Wurtsboro Fire Company No. 1.)

Dr. Charles W. Piper was elected the first chief of the Wurtsboro Fire Department. Three generations later, his descendants still serve in the department. (Courtesy of Wurtsboro Fire Company No. 1.)

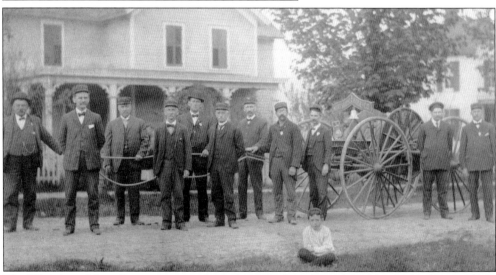

The Wurtsboro Hose Company poses for a photograph on Pine Street in 1905. The members, from left to right, are William Philcox, Joseph Holmes, William Delano, Andrew McCane, Louis Gumaer, Granston Bennett, Henry Peck, Charles Budd, George Harding, Chief Leo Smith, and Assistant Chief Daniel Woods. The boy in the foreground is Frank McCune Jr. His father, Frank McCune Sr., would eventually donate property to the firemen to build their hall in 1909. Sadly, Frank Jr. died 13 years later of influenza during World War I. The firemen's hall was eventually named in his honor and still keeps that name today. (Courtesy of Wurtsboro Fire Company No. 1.)

This photograph of the Wurtsboro firehouse was taken in 1969 shortly before its demolition. Built in 1909, the building served the firemen for 60 years. A more modern facility was erected in its place that same year and is still in use today. (Courtesy of Wurtsboro Fire Company No. 1.)

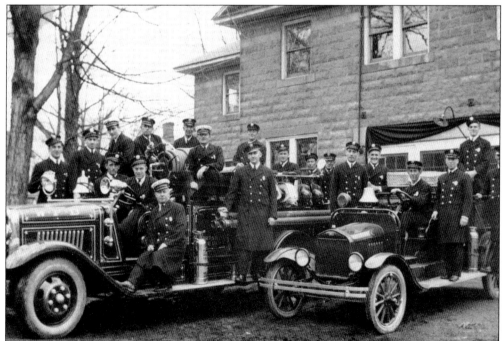

This photograph was taken in March 1939 after the funeral of Frank McCune Sr. McCune donated the property that the firefighters built their hall on in 1909. (Courtesy of Wurtsboro Fire Company No. 1.)

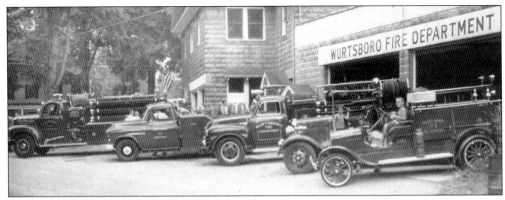

The Wurtsboro Fire Department displayed its fleet of apparatus in 1959. Peter Lindsay is seen sitting in the Model T while John Semonite looks on. (Courtesy of Wurtsboro Fire Company No. 1.)

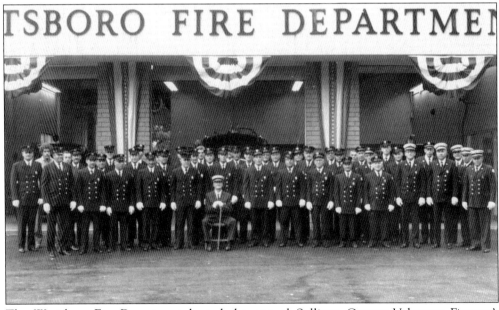

The Wurtsboro Fire Department hosted the annual Sullivan County Volunteer Firemen's Association parade in October 1972. As can be evidenced by this photograph, it had a good turnout for the event. (Courtesy of Wurtsboro Fire Company No. 1.)

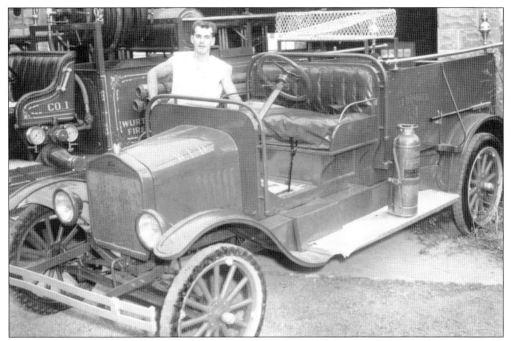

Frank Roosa, honorary chief of the Wurtsboro Fire Department, stands beside the 1918 Model T Ford fire truck he restored in 1959. The Model T was the first motorized apparatus of the department. (Courtesy of Wurtsboro Fire Company No. 1.)

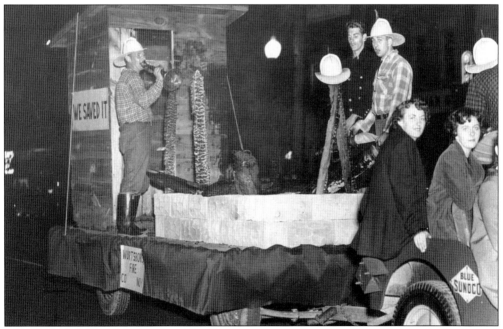

On October 3, 1953, the Wurtsboro Fire Department won first place for its "Saving the Outhouse" float at the Mardi Gras parade held by the Sullivan County Volunteer Fireman's Association in Monticello. Pictured, from left to right, are Gordon Piper, Frank Roosa, Wilbur Stanton, Marie (Roosa) Woodruff, and unidentified. (Courtesy of Wurtsboro Fire Company No. 1.)

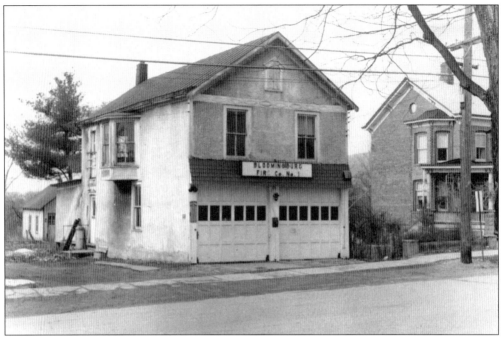

The first fire station in Bloomingburg was originally a store that was converted for use by the fire department in 1939. It served the community until 1964, when the present building was constructed. (Courtesy of the Bloomingburg Fire Company.)

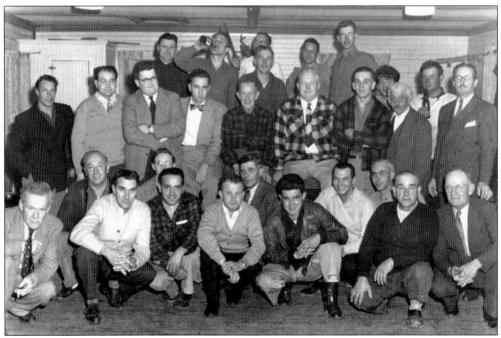

Some early members of the Bloomingburg Fire Company pose for the camera. (Courtesy of the Bloomingburg Fire Company.)

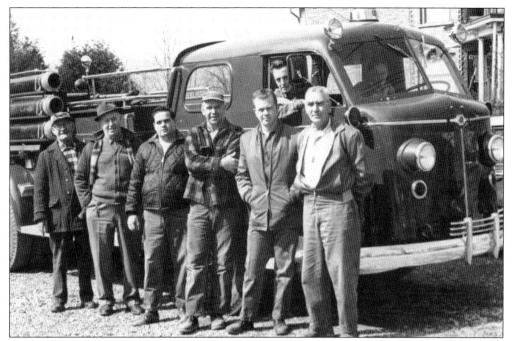
Bloomingburg firefighters pose in front of Engine 440. Pictured, left to right, are Russ Horrovoets, Russ Owen, Charles Walters, Walt Rogers, Norman Roosa, and Ken Godfrey. Bob Roe is in the cab and Russ Johnson is behind the wheel. (Courtesy of the Bloomingburg Fire Company.)

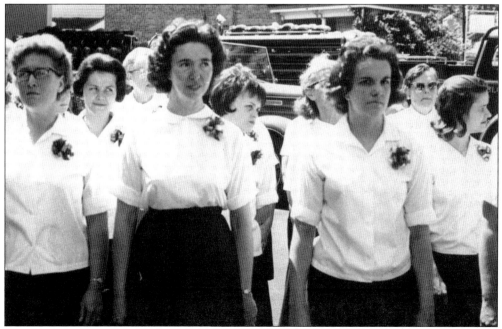
The Bloomingburg Fire Company's Ladies Auxiliary prepares to participate in the parade. Pictured, from left to right, are (first row) Edie Gillen, Marge Johnson, and Phyllis Brunning; (second row) Julie Johnson, Jackie Roosa, and Vivian Roe; (third row) Hazel Wood. (Courtesy of the Bloomingburg Fire Company.)

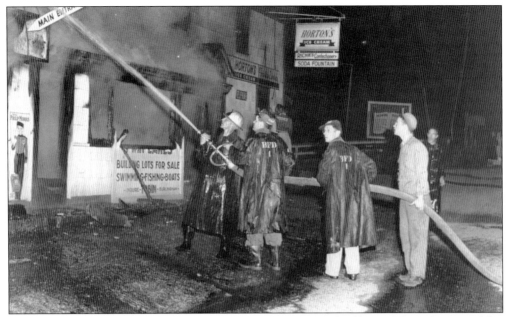

In July 1951, three fire departments were called out to battle the blaze of the Tobin Hotel fire in Burlingham. Although Patrick Tobin still owned the building, it was no longer a hotel at the time of its demise. Pictured fighting the fire, from left to right, are Stanley VanInwegen, Martin Amann, Leonard Collins, Richard Diffendale, and John Webster. (Courtesy of the Bloomingburg Fire Company.)

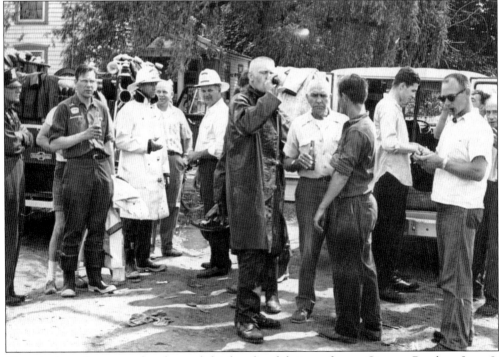

Bloomingburg firemen gather for cool drinks after fighting a fire on Stevens Road on June 8, 1966. (Courtesy of the Bloomingburg Fire Company.)

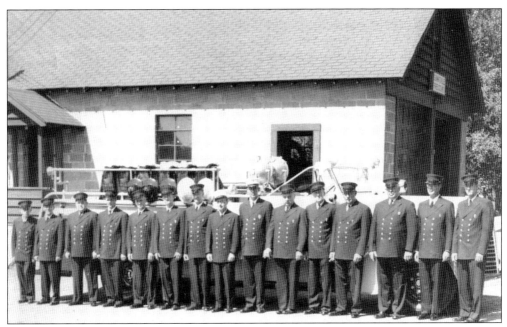

The first members of the Summitville Fire Department pose in front of their first firehouse for this early photograph. (Courtesy of the Summitville Fire Department.)

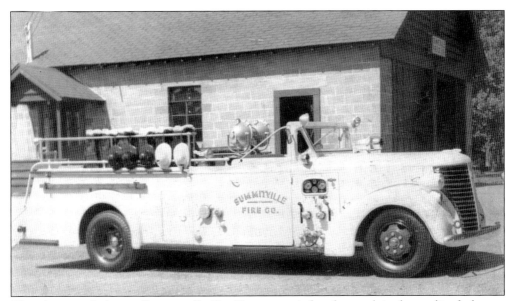

This photograph depicts Summitville Fire Department's first fire truck in front of its firehouse. (Courtesy of the Summitville Fire Department.)

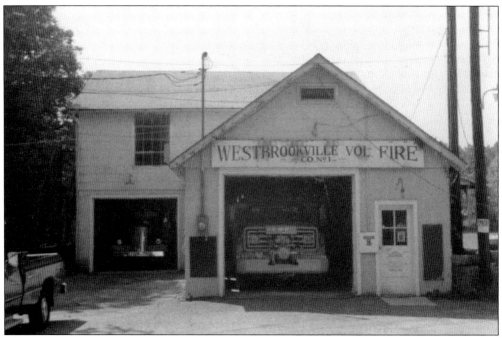

This was Westbrookville Fire Company's first official firehouse. It was built in 1950, and in 1962, the addition to the left was added on. This building was demolished to make room for the new truck house. (Courtesy of the Westbrookville Fire Department.)

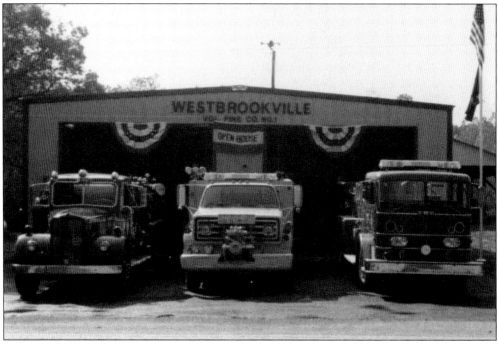

This Westbrookville firehouse was completed in September 1985. The trucks pictured, from left to right, are the 1956 Ward LaFrance pumper, the 1974 GMC Tanker, and the 1965 FWD Pumper. (Courtesy of the Westbrookville Fire Department.)

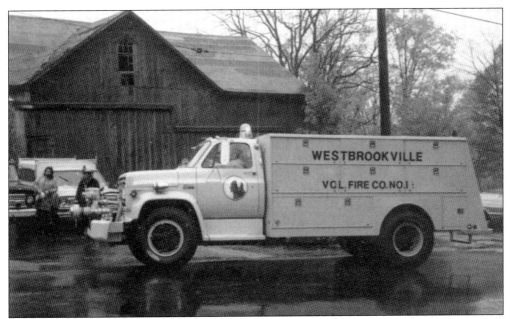

Westbrookville's 1974 GMC Tanker responds to an alarm on Pine Kill Road. (Courtesy of the Westbrookville Fire Department.)

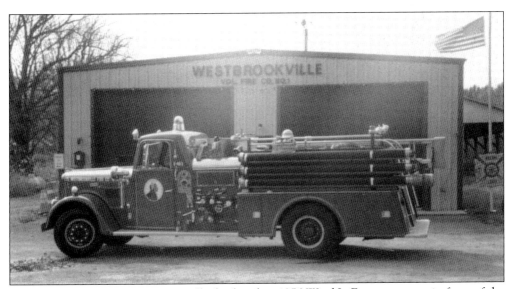

Westbrookville Fire Company proudly displayed its 1956 Ward LaFrance pumper in front of the firehouse for this photograph. (Courtesy of Westbrookville Fire Department.)

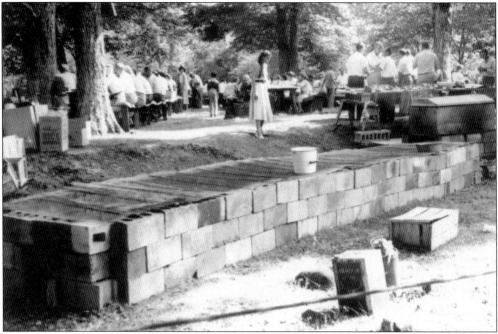

Westbrookville firemen held fund-raisers like this clambake to raise funds for construction of a new firehouse and to purchase new equipment. The clambakes were attended by hundreds of people from all over the area. (Courtesy of the Westbrookville Fire Department.)

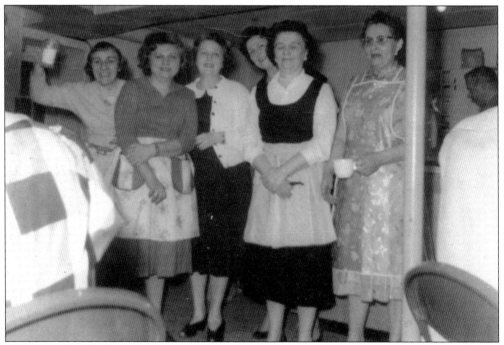

These Westbrookville ladies prepare another fine meal for a fund-raising event in 1961. Pictured, from left to right, are Rose Hohensteiner, Connie Sicuro, unidentified, Toby Weltman, Lu-Lu Skinner, and Kate Skinner. (Courtesy of the Westbrookville Fire Department.)

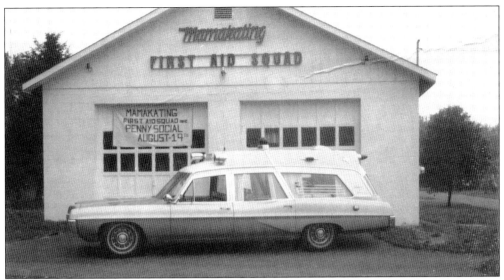

The Mamakating First Aid Squad was organized through the efforts of Harold Lindsay and Ross Horton on March 13, 1961, and it responded to its first call 19 days later. This building was constructed in 1962. (Courtesy of the Mamakating First Aid Squad.)

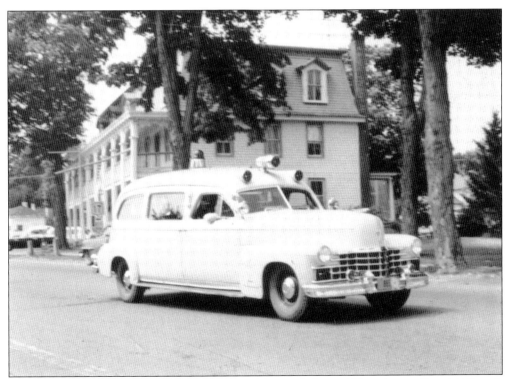

This 1947 Cadillac ambulance was the first rig of the newly formed Mamakating First Aid Squad. It was purchased for the squad by the Wurtsboro Chamber of Commerce from a volunteer squad in Ossining for $140. (Courtesy of Wurtsboro Fire Company No. 1.)

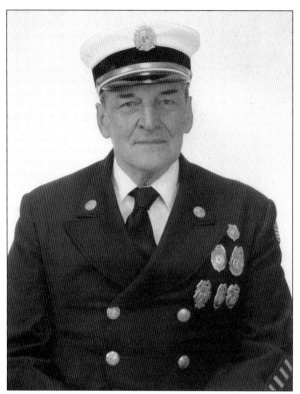

Michael Diamond was the first Jewish child to be born in the village of Wurtsboro. In later years, he served as mayor. He was also very devoted to the fire department, serving as its chief for several years. After his passing in 1988, the village established the Michael Diamond Memorial Foundation, which recognizes his lifetime of community service. (Courtesy of Arlene Diamond Borko and Deanna Mendels.)

Harold W. Lindsay was a lifelong resident of Wurtsboro. He served in the U.S. Army in World War II as a medic. He served the town of Mamakating in many capacities, including that of town historian. (Courtesy of Wurtsboro Fire Company No. 1.)

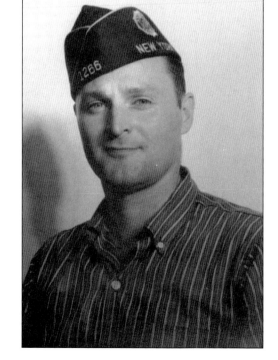

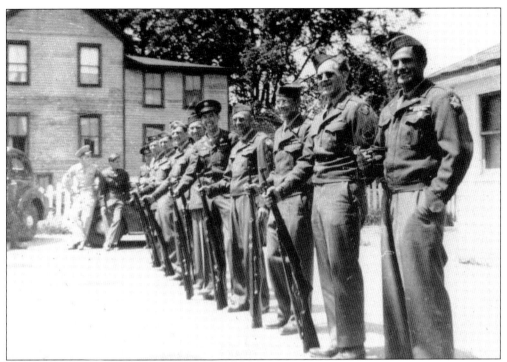
Wurtsboro's military veterans are all smiles as they line up for this photograph before the start of the Memorial Day parade. (Courtesy of Katherine Startup Houston.)

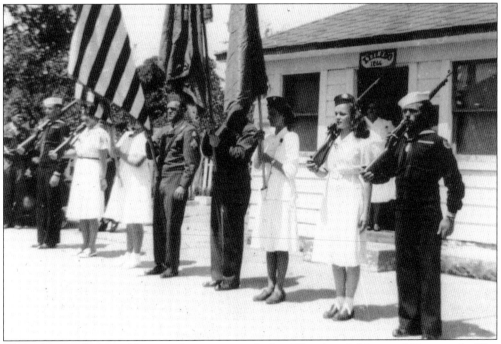
The military color guard lines up for inspection before Wurtsboro's Memorial Day parade. The lineup includes Tom Meyers (right) and June Clark Roosa (second from the right). (Courtesy of Katherine Startup Houston.)

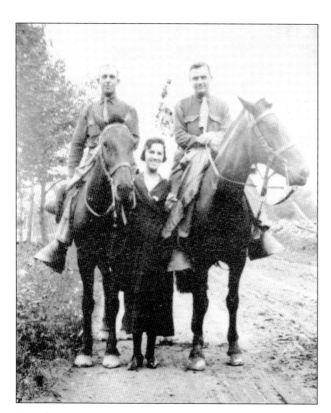

Ann McDonald stands with two New York state policemen on horseback in Wurtsboro. (Courtesy of Katherine Startup Houston.)

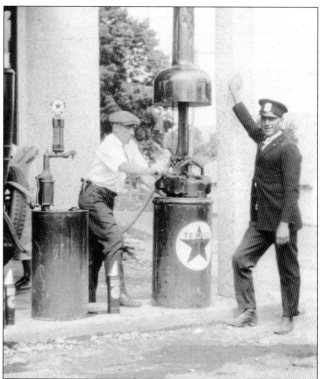

Robert J. Olcott (right) pauses at the Texaco station while making his rounds. Olcott was appointed a police officer for the village of Wurtsboro on June 5, 1925. (Courtesy of Robert J. Olcott.)

Four
NOTABLE EVENTS

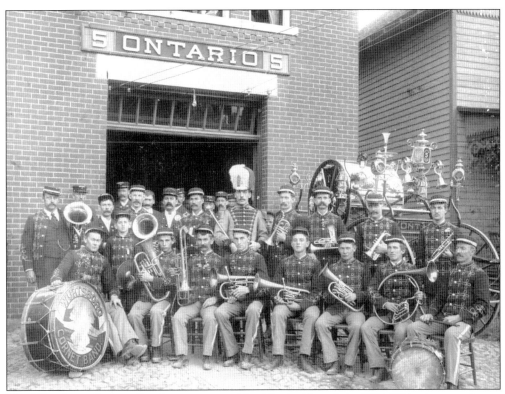

The Wurtsboro Coronet Band was organized by Charles Roesch in 1890. This photograph was taken on October 10, 1895, in front of the Ontario firehouse on North Street in Middletown. The band was hired to furnish the music for the Middletown fire parade. The band members, from left to right, are (first row) John Linton, Bill Benedict, Will Helm, George F. Harding, Lee Wakeman, Jim Benedict, Sam McCoubray, Fred Roesch, and Fred Babcock; (second row) William Harding, Melvin Babcock, William Godfrey, unidentified, Richard Day, William Bedford, Charles Roesch, and William Stanton Jr. (Courtesy of Wurtsboro Fire Company No. 1.)

In 1940, Wurtsboro fire chief Edward L. Wilkinson invited Helen Jepson, a nationally known Metropolitan Opera star, to march with the firemen at the county parade in Monticello. Jepson owned a summer home on Gumaer Falls just north of the village. Because she was under contract, she was only able to participate if she was made a member of the company. The company responded by making her an honorary chief, complete with a gold badge and a white helmet. Pictured with her, from left to right, are Wilkinson, Harry Farish, and C. P. Stanton. (Courtesy of Wurtsboro Fire Company No. 1.)

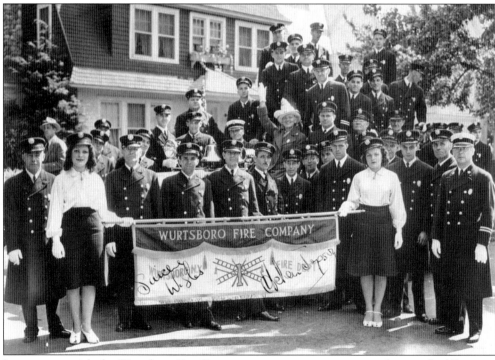

Jepson poses with the Wurtsboro Fire Company prior to participating in the parade. (Courtesy of Wurtsboro Fire Company No. 1.)

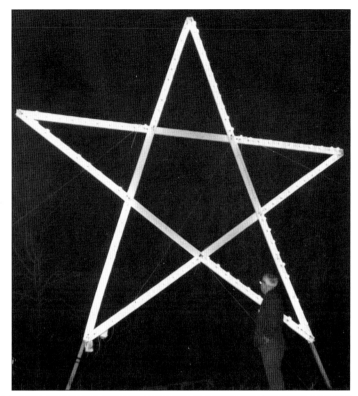

This 24-foot star was erected for the first time in December 1968 by the Wurtsboro Fire Company. It stands proudly each holiday season at the top of Tuxill Hill in Wurtsboro Hills and can be seen for miles. The property on which the star stands was once owned by Charles Tuxill, the founder of the Wurtsboro Hills development. (Courtesy of Wurtsboro Fire Company No. 1.)

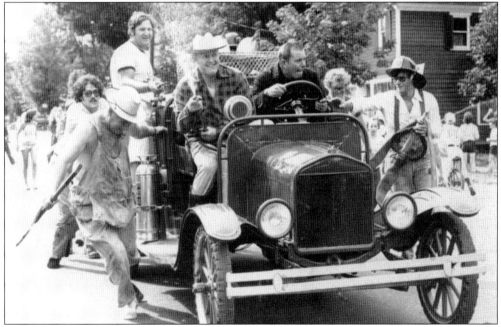

Members of the Wurtsboro Fire Company clown around during the Independence Day parade in 1978. Pictured from left to right are Gordon Piper, Jay Shapp, Bob Friedland, Bob Olcott, John Bryan, and John Bryan Jr. The 1918 Model T was Wurtsboro Fire Department's first motorized apparatus. (Courtesy of Wurtsboro Fire Company No. 1.)

Hundreds of spectators watch as the Mamakating Fife and Drum Corp marches during the 1976 bicentennial celebration in Wurtsboro. Pictured, from left to right are Julie Platt, Susan Semonite, Sarah Culver, Andrew Piper, Sherry Goetschius, June Piper, and unidentified. (Courtesy of the Holmes family.)

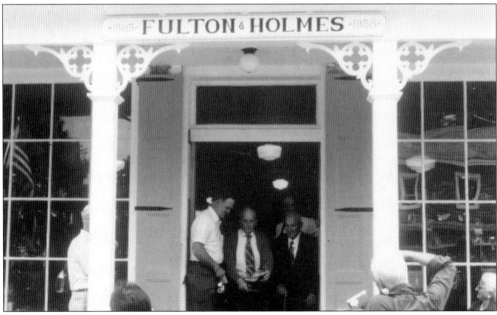

The grand reopening of the Holmes family store, Canal Towne Emporium, took place in 1976. Pictured in the doorway, from left to right, are Lyman Holmes, grandson of the original store proprietor; George Olcott, head clerk for Fulton and Holmes for nearly 50 years; and Michael Mokarzel, the last surviving Delaware and Hudson canal boat captain. (Courtesy of the Holmes family.)

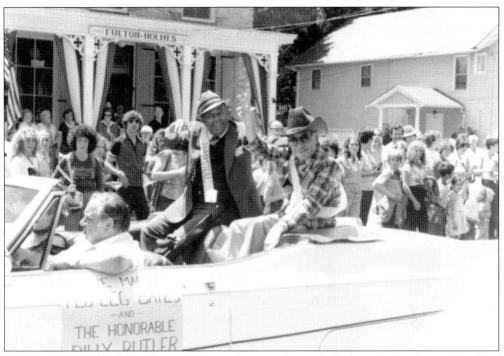

Peg Leg Bates and Billy Butler were honored as parade marshals during Wurtsboro's Fourth of July parade in 1980. (Courtesy of Jack and Toni Haley.)

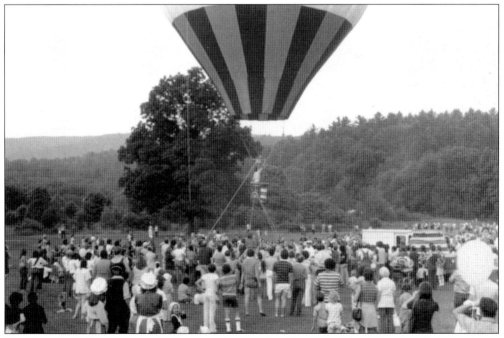

The hot-air balloon was a huge attraction at the bicentennial celebration in Wurtsboro. (Courtesy of the Holmes family.)

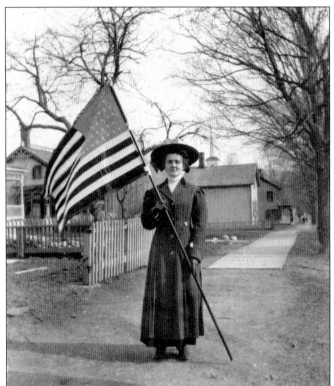

Leah Olcott Stanton was a local champion of women's rights and the suffrage movement. This 1909 photograph was taken on Sullivan Street in Wurtsboro in front of the Rosemont House. (Courtesy of Robert J. Olcott.)

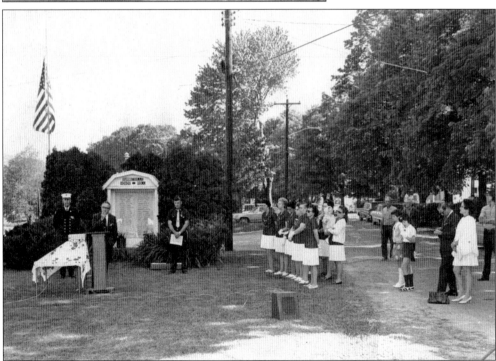

Those who have fought for the country's freedom are remembered at this Memorial Day gathering in Summitville in 1972. (Courtesy of Walt Finkle.)

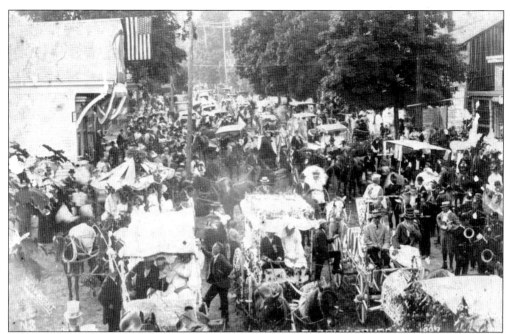

Around 1900, Bloomingburg was a popular place for summertime visitors. Coaching parades were very popular. Every boardinghouse entered a rig of some kind, and churches and fraternal organizations entered modest floats. There were booths throughout the village that served food and beverages. Every coach was beautifully decorated and filled with people in costume. The event became so well known that the New York, Ontario and Western Railroad sold excursion tickets to the gala. This photograph was taken in 1897. (Courtesy of Loretta Franklin.)

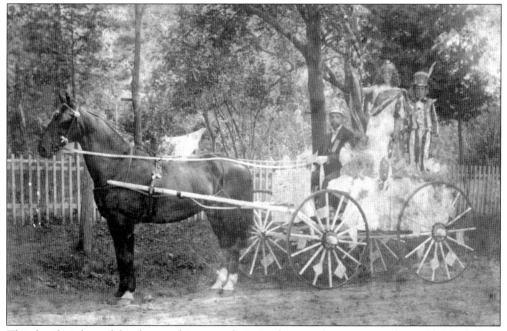

This family is bound for the coaching parade in its decorated wagon complete with Uncle Sam and Lady Liberty. (Courtesy of Loretta Franklin.)

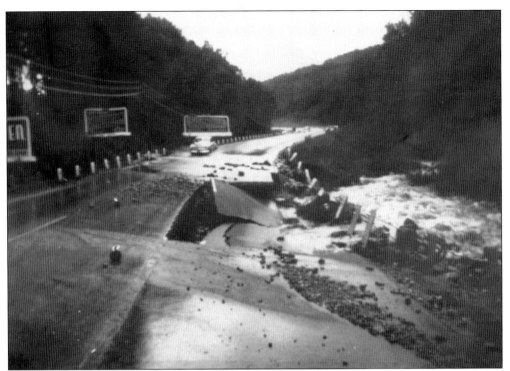

Thousands of vacationers were left stranded after Hurricane Diane hit the area in August 1955. The flooding was widespread, and as a result, many roads were washed away. This photograph shows a section of old Route 17 just west of the village of Wurtsboro. (Courtesy of Greg D. Karpinsky.)

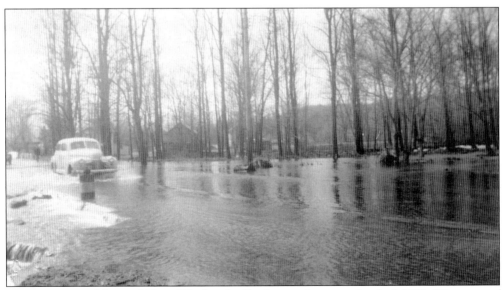

This is a view of Route 209 in Westbrookville during the great flood of 1955. (Courtesy of Elizabeth Laden.)

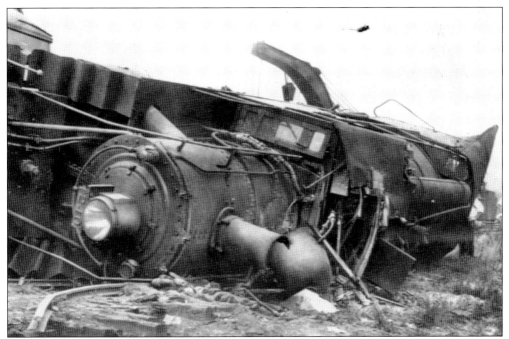

On July 24, 1933, a passenger locomotive struck a stalled vehicle on the tracks in Summitville. Engineer Seth Jackson died after being severely burned by live steam. (Author's collection.)

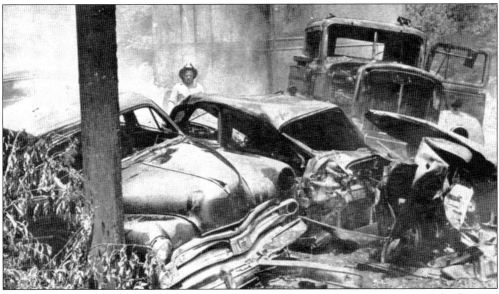

This pileup occurred on Sunday, July 8, 1951, after a truck loaded with propane cylinders ran wild down Wurtsboro Mountain Road after its brakes failed. It crashed at a terrific speed into a long line of cars heading back to New York City after spending the weekend in the Catskills. Three people burned to death after becoming trapped in their car, and one person succumbed to his burns later. Twenty others were seriously injured, and 10 vehicles were completely demolished. This catastrophe made headlines across the nation. (Courtesy of Wurtsboro Fire Company No. 1.)

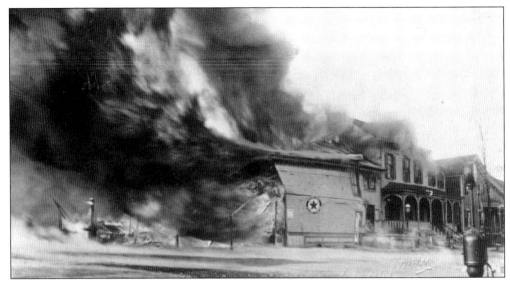

On the afternoon of February 24, 1922, a small fire started in Phil Greco's barbershop on Main Street in Bloomingburg. It started from an overheated woodstove and soon spread to Collins' store, the neighboring shops, VanInwegen's funeral parlor, and two residences along the North Road. Due to high winds, the fire spread to the opposite side of the street, completely consuming John K. Evans's store and home and Bennett's Hotel. (Courtesy of the Hultslander family.)

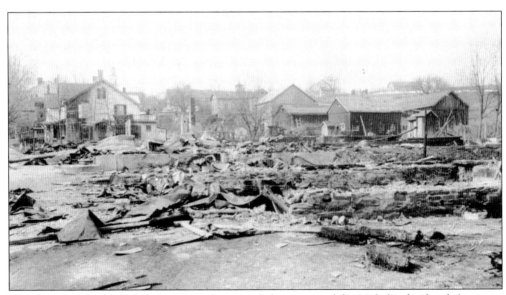

The day after the fire, Main Street lay devastated. (Courtesy of the Hultslander family.)

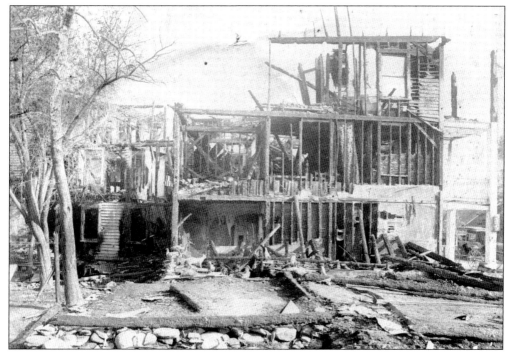
This photograph shows the remains of the Butler Hotel, formerly the Olcott House, which burned to the ground on March 8, 1923. (Courtesy of Wurtsboro Fire Company No. 1.)

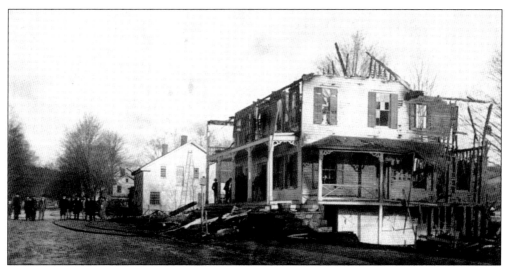
On March 31, 1909, the Wurtsboro House, formerly the Harding House, burned beyond repair. This hotel was located on Sullivan Street, on the Delaware and Hudson Canal. (Courtesy of the Lindsay-Dunn collection.)

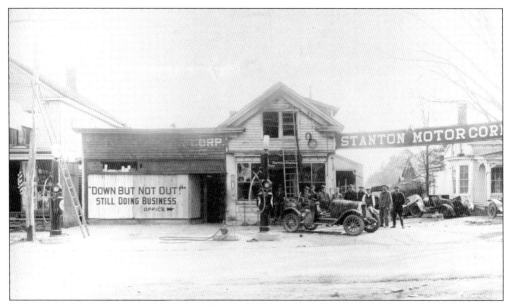

At 1:00 a.m. on May 25, 1925, the church bell sounded the call for help: Stanton's Motor Corporation was burning. The garage was very badly damaged in the fire, but the firemen made a good stop that spared all of the surrounding buildings from the blaze. Notice the sign in front that reads, "Down But Not Out! Still Doing Business." (Courtesy of Wurtsboro Fire Company No. 1.)

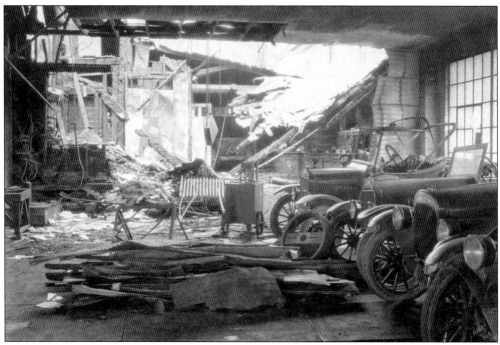

This photograph shows the extent of the damage inside Stanton's garage the morning after the fire. (Courtesy of Wurtsboro Fire Company No. 1.)

Five

RECREATION

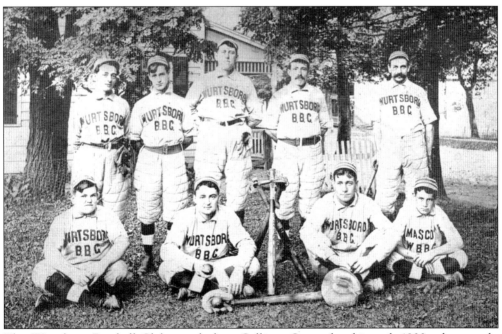

The Wurtsboro Baseball Club posed along Sullivan Street for this early-1900s photograph. (Courtesy of Kevin and Tish Moore.)

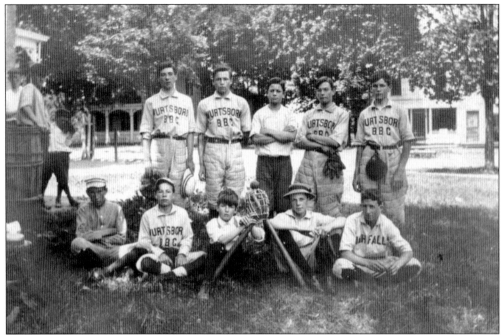

The Wurtsboro Baseball Club took a break from its game for this July 1908 photograph. (Courtesy of Robert J. Olcott.)

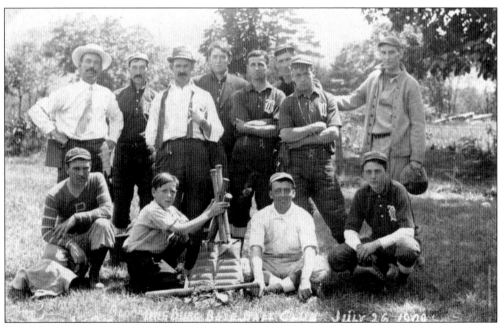

The Bloomingburg Baseball Club poses for a team photograph on July 26, 1909. Among the players are Tom Flaherty, Don Bell, William Holbert, Charles Tracy, Clayton Jones, Louis Bell, Bill Fagley, and Joe Rogers Jr. (Courtesy of the Bloomingburg Restoration Foundation.)

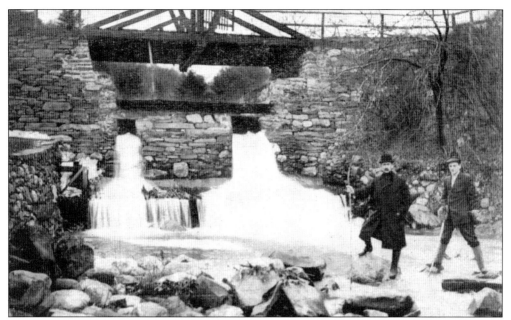

Mamakating is home to some of the most scenic hiking trails in Sullivan County. These gentlemen are pictured along the Valentine's Dam in Wurtsboro nearly a century ago. (Courtesy of Jack and Toni Haley.)

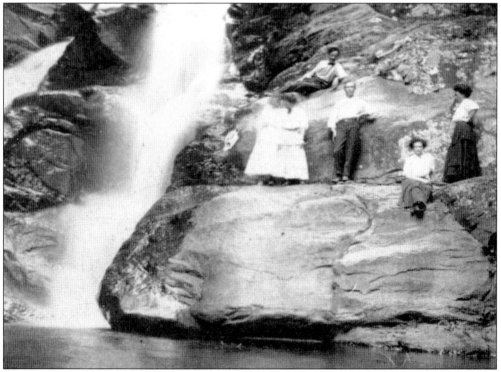

Joe McDonald and his family enjoy the beauty of Gumaer Falls in this photograph from around 1900. Gumaer Falls is perhaps the most picturesque waterfall in Sullivan County and is located just north of Wurtsboro. (Courtesy of Kevin and Tish Moore.)

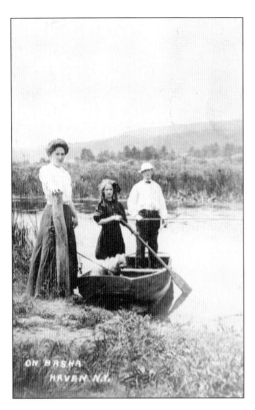

Basha Kill is a tranquil wildlife habitat and recreation area located just south of Wurtsboro. The Basha Kill area is a nationally known wildlife management area that has been owned by the State of New York since 1972. People have enjoyed the peace and tranquility of Basha Kill for hundreds of years. (Courtesy of Elizabeth Laden.)

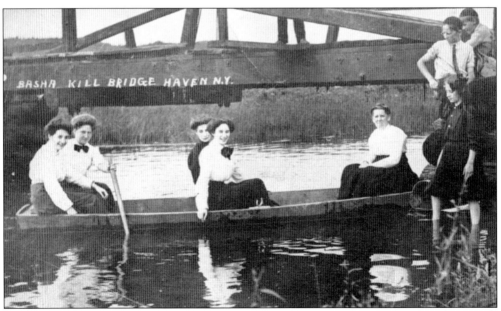

Boating on the Basha Kill has always been a popular pastime, as evidenced by this photograph from about 1900. (Courtesy of the Lindsay-Dunn collection.)

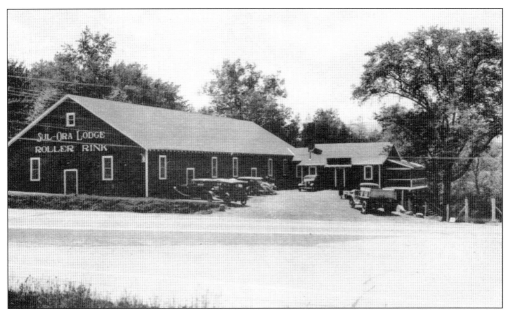

Many Mamakating residents have fond memories of the Sul-Ora Lodge. It was built by DuBois Collins in 1938 as a complete recreational facility on the bank of the Shawangunk Kill. It offered roller-skating, swimming, boating, fishing, and picnicking until it was sold in 1967. The skating rink remained open for a few years longer. (Courtesy of the Lindsay-Dunn collection.)

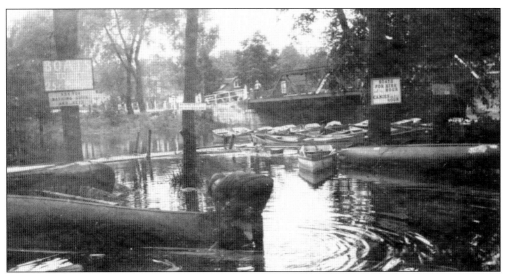

Boats and canoes were available to rent by the hour at the Sul-Ora recreational facility on the Shawangunk Kill in Bloomingburg. (Courtesy of the Bloomingburg Restoration Foundation.)

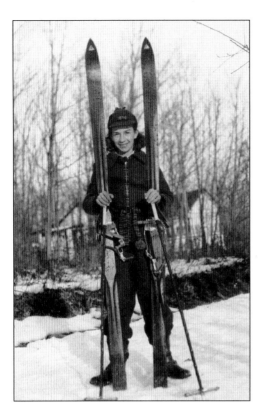

Cross-country skiing was an all-time favorite winter sport on the trails in Wurtsboro Hills. This 1940s photograph shows Patricia (Auer) Moore, past mayor of Wurtsboro and past town of Mamakating clerk, posing with her skis. (Courtesy of Patricia Moore.)

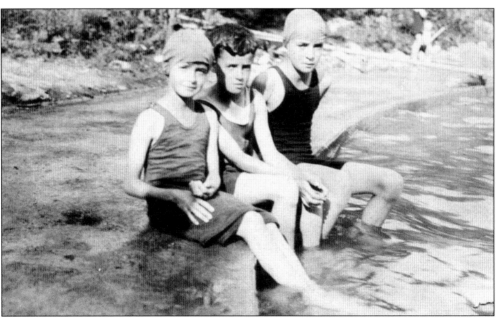

Few people are aware of the spring-fed swimming pool that once existed in Wurtsboro Hills. The pool was only a short distance from the community lake that still operates today. Rosemary, Robert, and Joseph Worthington take a break from swimming to pose for this photograph in 1927. (Courtesy of Agnes and Jack Haley.)

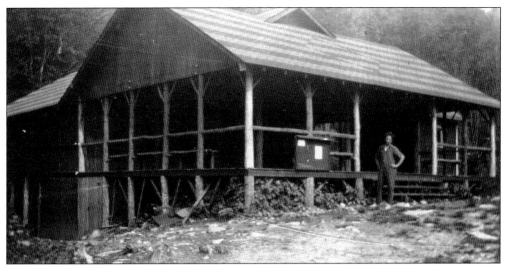

The Wurtsboro Hills Casino first opened on Memorial Day in 1925. It included one of the finest dance floors in Sullivan County, upon which nearly 300 couples could enjoy themselves without being overcrowded. The casino was situated within close proximity of the community lake. (Courtesy of Andre and Yvonne Caradec.)

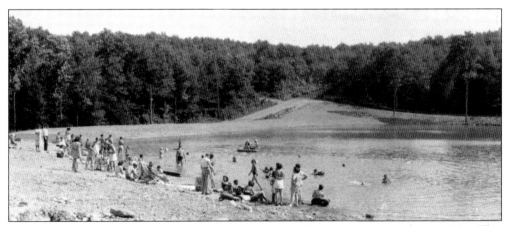

Bathers gather along the shore of the Wurtsboro Hills Community Lake in 1951. This photograph was taken from where the concession stand is located today. Community members still enjoy the lake that Charles Tuxill created more than a half century ago. (Courtesy of Kevin and Tish Moore.)

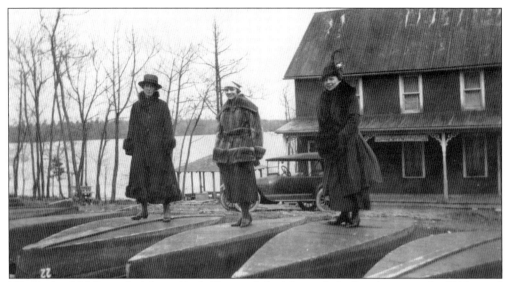

Ella Durland Millspaugh Adams (far left) owned the Masten Lake Boathouse in the 1920s until a fisherman accidentally burnt it down after starting a fire under the porch. The property was sold shortly thereafter. (Courtesy of Phyllis M. Norton.)

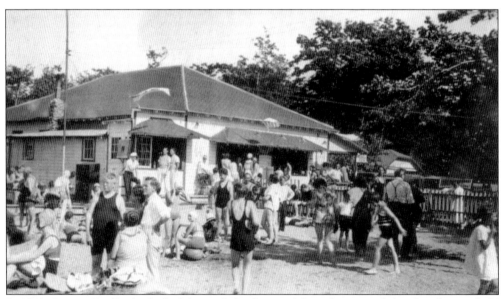

In 1923, George Sniffen built the Masten Lake Casino. Many dances with live bands were held there in the 1920s and 1930s. The casino also contained a jukebox, a bowling machine, pinball machines, Ping-Pong tables, and a piano. Sunbathers were able to rent 100 percent wool Jansen bathing suits, and nearly 70 lockers were available so that they could safely store their belongings. Candy, ice cream, soda, and hot dogs were available for the swimmers as well. (Courtesy of Phyllis M. Norton.)

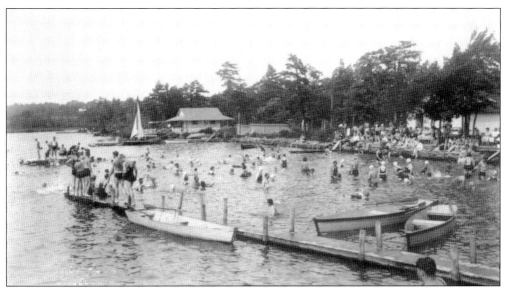

Masten Lake was a popular destination for boating, swimming, and sunbathing. It is interesting to note that the roof of the casino, the rafts, the trim on the boats, and the oars were all painted orange, as the owner felt that it was the best way to attract attention. (Courtesy of Phyllis M. Norton.)

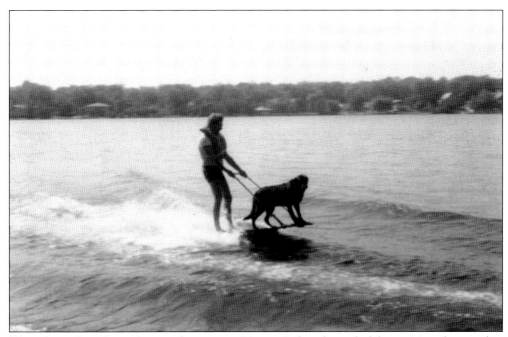

Waterskiing has always been a favorite on Masten Lake, the only lake in Mamakating that allows motorboats. Ralph Benson and Hannibal, the Wurtsboro Airport Mascot, are pictured here riding the waves. (Courtesy of the Benson family.)

This photograph shows the dining room of Smithem's Hunting Camp around 1916. The camp, located on Yankee Lake, consisted of seven cabins, a dining hall, and a dance hall. In later years, William P. Smithem added a store to the camp and received permission from the government to operate a summer post office on site. (Courtesy of the Lindsay-Dunn collection.)

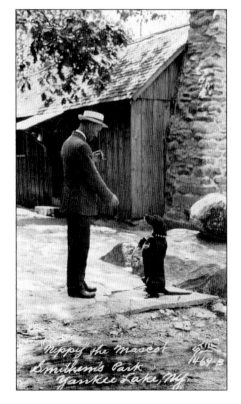

Nippy, the mascot of Smithem's Park in Yankee Lake, sits up for a treat. The dog was believed to be owned by Henry Still, a prominent area photographer of the day and a frequent visitor to the park. (Courtesy of the Lindsay-Dunn collection.)

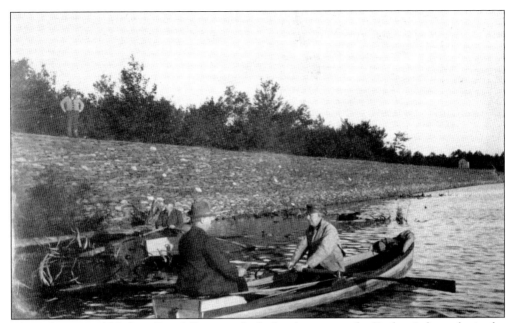

The Delaware and Hudson Canal Company built this dam across the Yankee Lake outlet in the mid-1800s. In 1894 and 1895, it was enlarged and now measures 525 yards long, 52 feet wide at its base, 26 feet wide at the top, and 22 feet high. It took 30 men working nearly two years to build it. (Courtesy of Robert J. Olcott.)

This early image shows residents along the Yankee Lake shore. (Courtesy of Linda J. M. Tintle.)

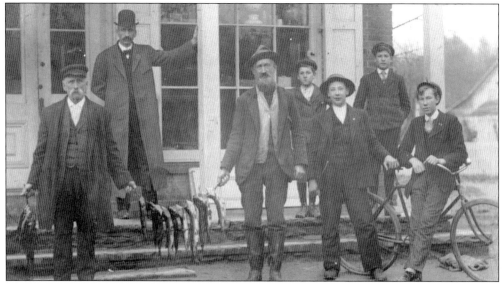

Mamakating's numerous lakes have always been renowned for their bountiful fishing. This photograph was taken on November 22, 1907, in front of the Fulton and Holmes Store on Sullivan Street in Wurtsboro. (Courtesy of the Lindsay-Dunn collection.)

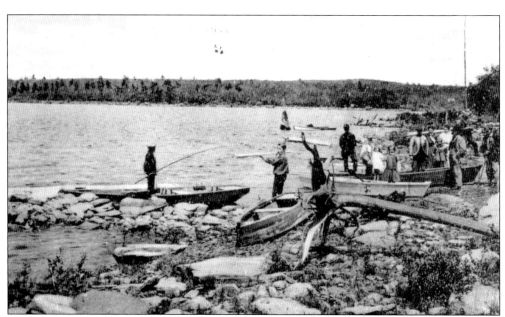

Vacationers gather along the shoreline at Smithem's Camp on Yankee Lake. Few lakefront properties of that day had sandy beaches, and many were plagued with rocks and tree stumps, so Smithem's Camp was a popular spot in the summer. (Courtesy of Linda J. M. Tintle.)

Hunting was and still is a very popular sport in Mamakating. Many cabins and bungalows were used as hunting retreats. Ed Benson of Wurtsboro poses with his buck in the early 1900s. (Courtesy of the Benson family.)

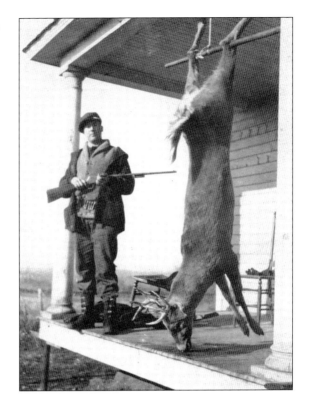

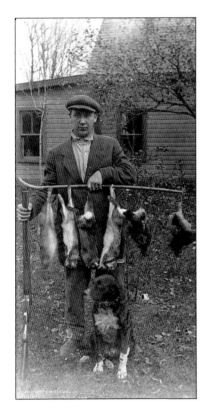

Village of Wurtsboro resident Percy Newkirk is pictured here with his faithful hunting dog, Sport. He is proudly displaying his take for the day. This photograph was taken around 1910. (Courtesy of the Newkirk family.)

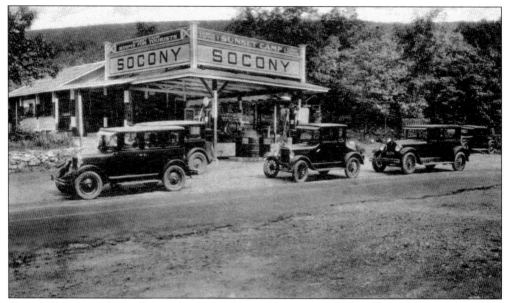
Sunset Camp was located just above the hairpin turn east of Wurtsboro. The camp offered gasoline, rooms for rent, and food for tourists. (Author's collection.)

These campers enjoy the scenic valley view of Wurtsboro from Sunset Camp. (Author's collection.)

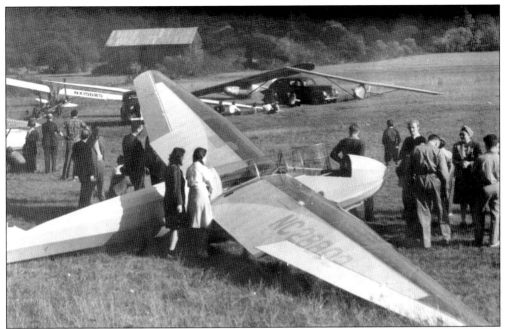

Established in 1926, the Wurtsboro Airport is the oldest soaring destination in the United States. The wind patterns in this part of the valley are ideal for sailplane pilots. (Courtesy of Joseph M. Bennis.)

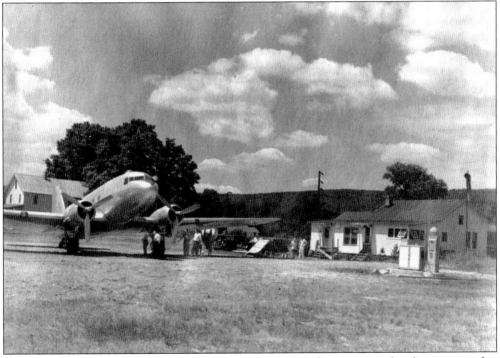

Onlookers gather around an airplane in front of the Wurtsboro Airport luncheonette in this early photograph. (Courtesy of Joseph M. Bennis.)

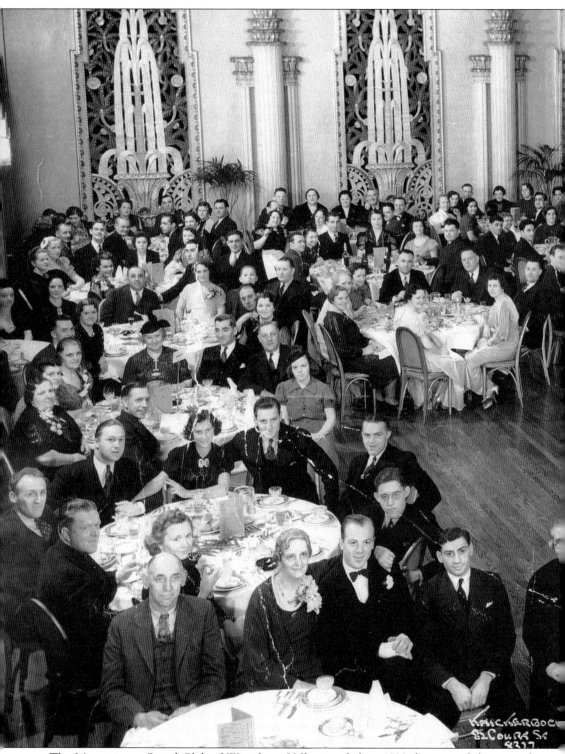

The Mountaineer Social Club of Wurtsboro Hills attended its 1938 dinner and dance at the Hotel Victoria in New York City. Among the guests were Jack Haley Sr., Charlie Winkler, Frank

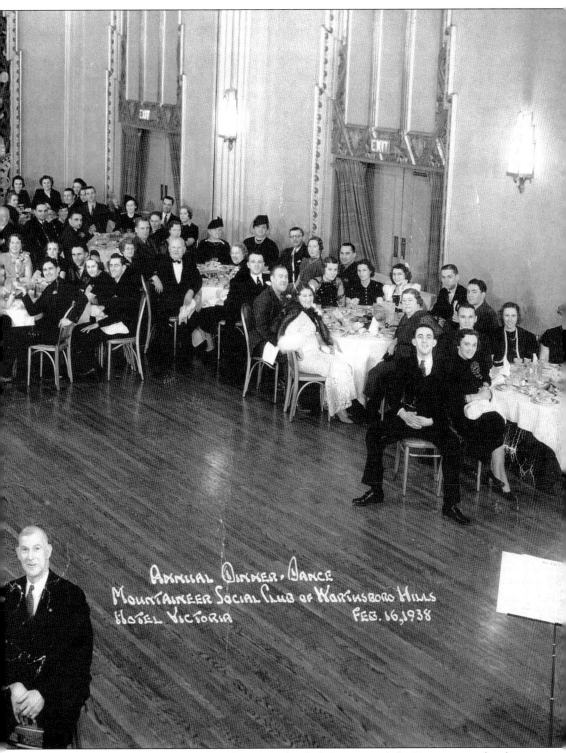
and Hazel Curcio, the Fred Rueger family, Agnes (Haley) Rueger, and the Timmerman family. (Courtesy of Agnes and Jack Haley.)

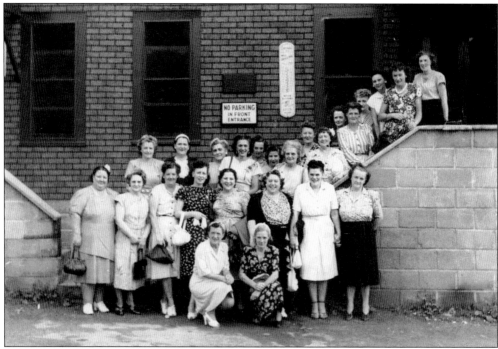

This early-1940s photograph of the Mountainette's Club was taken in front of Curcio's Tavern in Wurtsboro Hills during one of its gatherings. (Courtesy of Agnes and Jack Haley.)

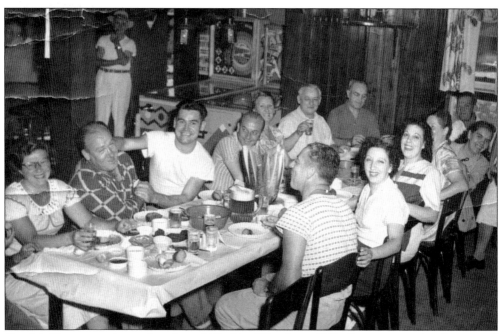

Curcio's Tavern was located on Laurel Trail in Wurtsboro Hills. It was a popular dining and dancing destination in the 1940s and 1950s. Pictured are Jake Timmerman (second from left) and Andre Caradec (third from left) sharing a laugh with some friends. (Courtesy of Andre and Yvonne Caradec.)

Six
SCHOOLS AND PLACES OF WORSHIP

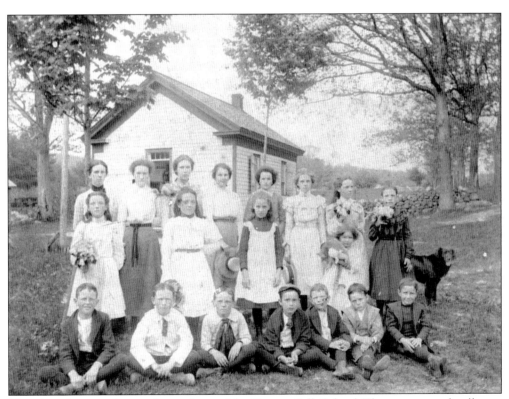

This class photograph was taken in front of the Gumaer Falls School. The one-room schoolhouse once stood near the intersection of Gumaer Falls Road and Route 209 in Wurtsboro. (Courtesy of Kevin and Tish Moore.)

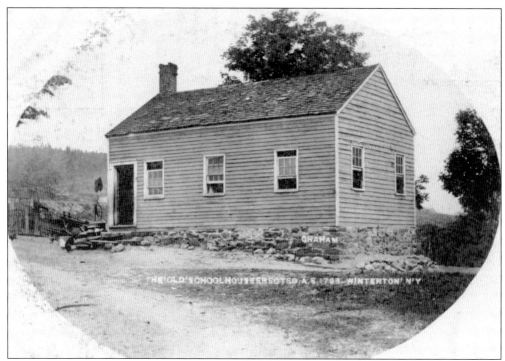

This one-room schoolhouse was built in 1798 in Winterton. It still stands on the corner of Winterton and Buttonwood Roads. (Courtesy of the Hultslander family.)

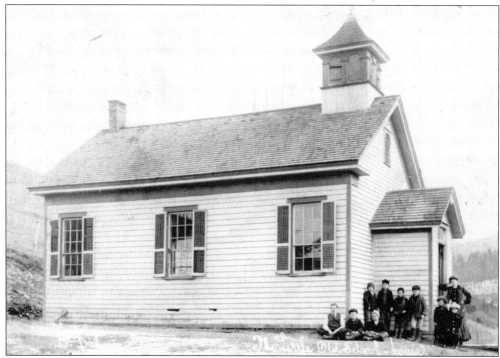

This little, old schoolhouse on Sandberg Bend was once located in Spring Glen. (Courtesy of the Mamakating Historical Society.)

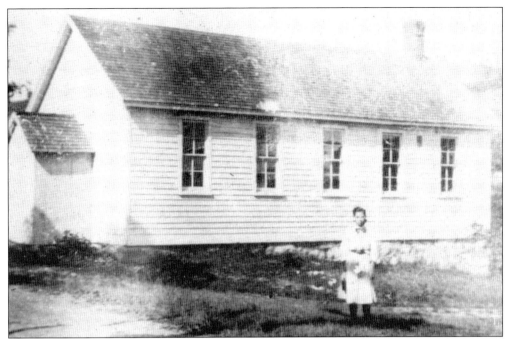

This c. 1907 photograph is of the High View School, which was located on Boris Road and the Old Cochecton Turnpike. The school closed in 1913 when the district merged with Bloomingburg. It is still standing today but has been converted into a private home. (Courtesy of the Lindsay-Dunn collection.)

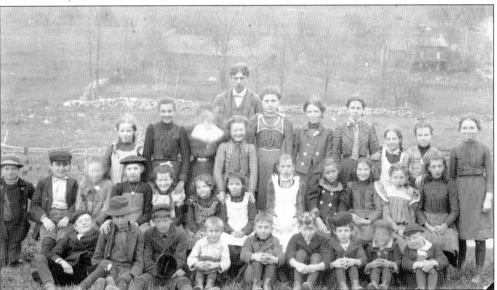

Pupils of the High View School pose for this photograph in 1898. Among the students are Irene Kerwin, Sarah Barrett, George McDermott, Lena Davison, Ruth Davison, Bessie Kerwin, Cassie Langley, Ethel Rogers, Clayton Jones, Hattie Barrett, Anna Howard, Charles Pedfield, Eva Babcock, Ruth Godfrey, Pete Lyons, Clyde Davison, Ed Hultslander, George Barrett, Earl Davison, Russel Brigge, C. Rogers, and Neil Hultslander. (Courtesy of the Bloomingburg Restoration Foundation.)

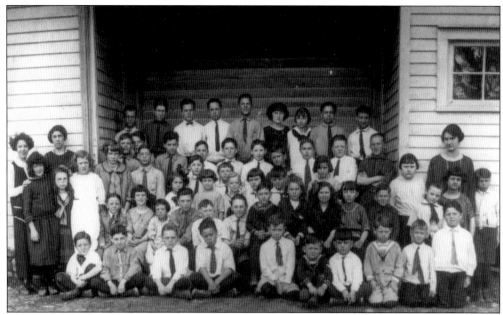

In 1925, the Wurtsboro Grade School students posed for this photograph in front of the three-room schoolhouse that still stands on the southeast corner of Pine and Fourth Streets. (Courtesy of Mardell Auer.)

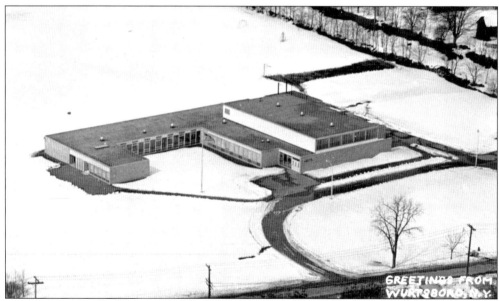

This aerial view of the Emma C. Chase School in Wurtsboro was taken in 1964. Students entered the school for the first time on November 20, 1959. They met that morning at the old school on Fourth Street, collected their books and belongings, and walked to the new school at 9:00 a.m. (Courtesy of Robert J. Olcott.)

The Phillipsport Methodist Episcopal Church was built in 1823 and was the first Methodist church in Sullivan County. Before the church was built, worship services were conducted by circuit riders who would preach in the area every six weeks. (Courtesy of Linda J. M. Tintle.)

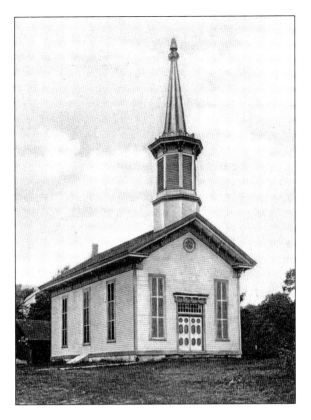

The Phillipsport Methodist Episcopal Church served the area for many years after it was built in 1823. In later years, as the population dwindled, the church merged with Summitvillle and worship services in Phillipsport ended. The building sits vacant today. (Courtesy of the Lindsay-Dunn collection.)

This Methodist church located on Pinekill Road in Westbrookville was built in 1891 and has been actively serving the community ever since. (Courtesy of Elizabeth Laden.)

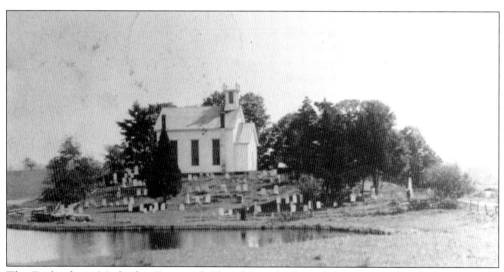

The Burlingham Methodist Episcopal Church was built on land donated by the Dietz family in 1829. The church thrived in the late 1800s, primarily in the summer, when large numbers of tourists came to the area to vacation. Over the years, the population dwindled to a low of six worshippers in the late 1930s, and the church was closed. After several years of neglect, the church was deemed beyond repair and was sold in 1948 for $105—roughly the value of its lumber. It was razed in the spring of that year, leaving only the cemetery on the knoll where it once stood. (Courtesy of the Hultslander family.)

The Dutch Reformed Church of Bloomingburg has been in existence since 1821. The cost to build the church was $5,000, and it had a seating capacity of 500. Due to consolidation, church services ceased in 1968. The building served as a church school for the combined churches until 1971. In 1972, it was given to the county, and through the efforts of the Bloomingburg Restoration Foundation, it has become a museum and cultural center. (Courtesy of Loretta Franklin.)

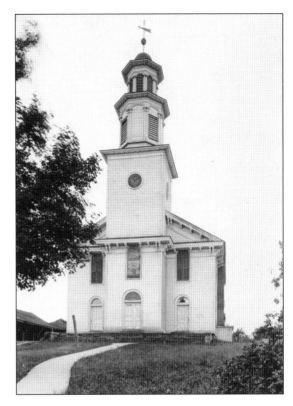

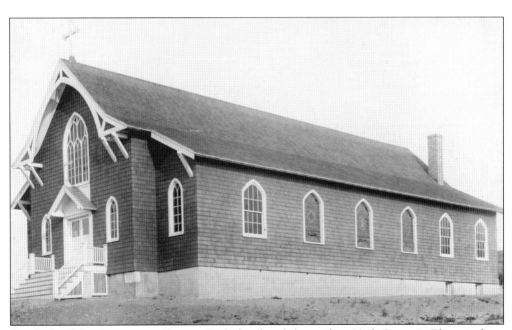

Our Lady of the Assumption Roman Catholic church located on High Street in Bloomingburg was built in 1913 and still serves the community today. (Courtesy of Loretta Franklin.)

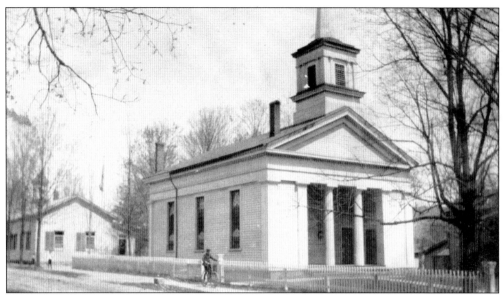

The Dutch Reformed Church in Rome was organized on August 5, 1805, and was the first church in the village. Rome was the name for Wurtsboro prior to the construction of the Delaware and Hudson Canal. The construction of this church began in 1846 and took three years to complete. The building just behind the church was the public schoolhouse. After the Emma C. Chase School was built, the old school was sold to the church, which continues to use it as a hall today. (Courtesy of the Mamakating Historical Society.)

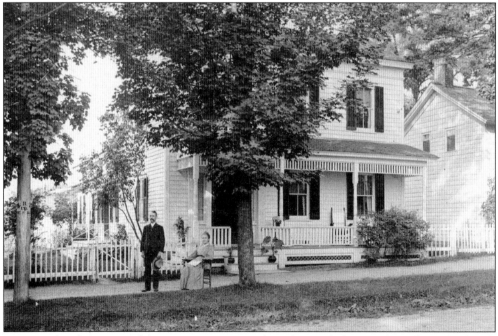

Rev. Josiah E. Crane and his sister are pictured in front of the Dutch Reformed Church parsonage on Sullivan Street in Wurtsboro. Crane ministered here from 1900 until 1917. The home eventually fell into disrepair and was torn down in 1961. (Courtesy of Wurtsboro Fire Company No. 1.)

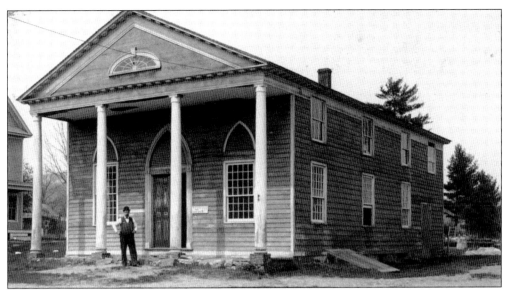

The first Methodist church in Wurtsboro was built in 1832 and was located on the northwest corner of Pine and Third Streets. It was sold in 1890 for $200 to Jacob Helm, who used it as a woodworking shop. The money was used to offset the cost of purchasing the property along Sullivan Street where the new church was built. This building changed hands several times throughout the years and was eventually torn down. (Courtesy of Wurtsboro Fire Company No. 1.)

This wooden Gothic-style Methodist church was erected on Sullivan Street in Wurtsboro in 1890. The total cost for its construction was $3,478.11. Due to consolidation, the church eventually closed. It was later purchased and converted into a garden shop and a café. (Courtesy of Wurtsboro Fire Company No. 1.)

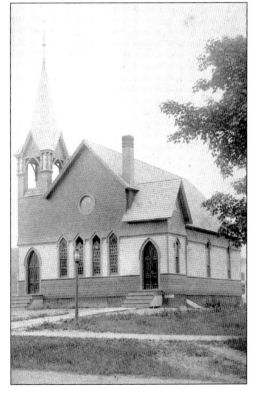

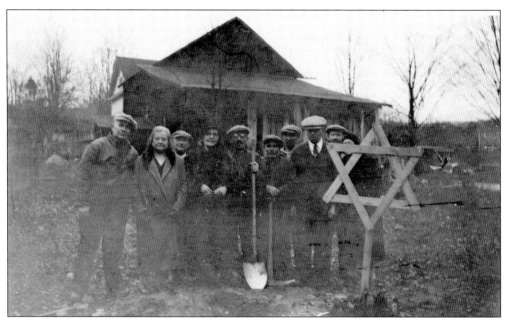

This groundbreaking ceremony at the Wurtsboro Synagogue site occurred in 1931. (Courtesy of Esther D. Levine.)

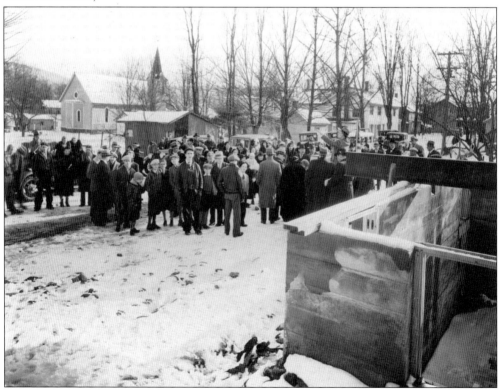

On February 6, 1932, the entire Jewish population of Wurtsboro, together with many of the area townspeople, gathered on Third Street to attend the cornerstone-laying ceremony for the Wurtsboro Synagogue. (Courtesy of Esther D. Levine.)

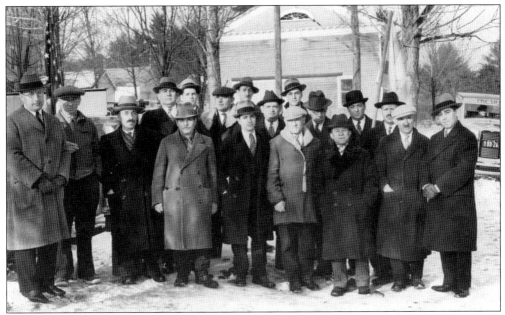

The officers, charter members, and friends of the Wurtsboro Synagogue pose for this photograph at the cornerstone-laying ceremony on February 6, 1932. Pictured, from left to right, are (first row) unidentified, Louis Schwartz, Solomon Diamond, Louis Friedland, Morris Zaritsky, Samuel Kaufman, Morris Schwartz, Max Gerber, and Herman Levine; (second row) Abraham Cohen, Samuel Diamond, Ely Kaufman, Jack Diamond, Philip Needle, Michael Diamond, Samuel Schmeir, Paul Diamond, and Jacob Trachtenberg. (Courtesy of Esther D. Levine.)

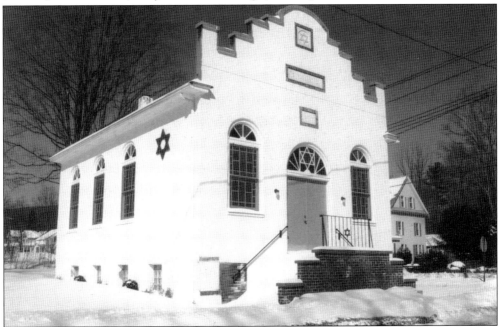

The Wurtsboro Synagogue has been proudly serving the community since 1932. The property on the southwest corner of Third and Pine Streets was purchased by the Hebrew Congregation in 1931 for $400. (Author's collection.)

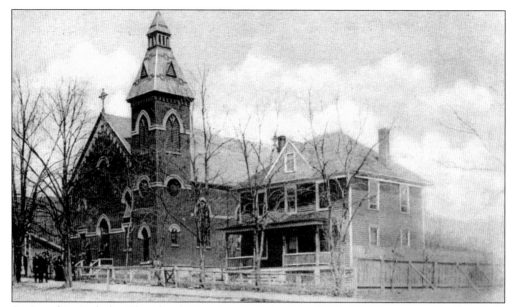

St. Joseph's Catholic Church of Wurtsboro was built in 1880. The rectory was built shortly thereafter. The church continues to serve the community today. The first Catholic church building in Mamakating was purchased from the Dutch Reformed Protestant Church and was reported to be the oldest edifice in the county. The brick church that stands today was built on the same site as the original church. (Courtesy of the Lindsay-Dunn collection.)

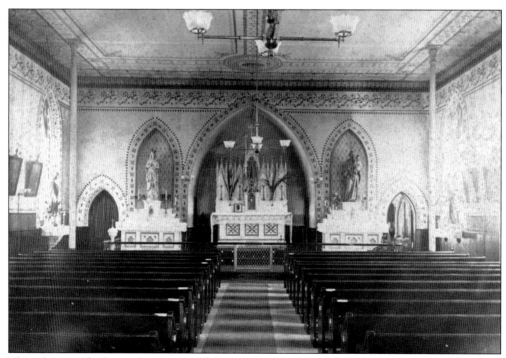

This photograph shows the interior of the newly constructed St. Joseph's Catholic Church in the late 1800s. (Courtesy of St. Joseph's Church.)

Seven
Transportation

Frank McCune Jr. and his sister Marie are pictured in the family horse and carriage. Their father, Frank McCune Sr., was the owner of the Dorrance House and Annex in Wurtsboro. (Courtesy of the Masten family.)

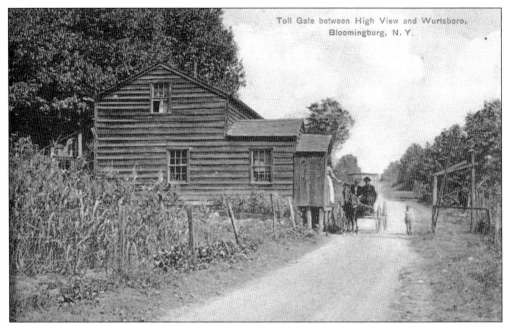

This tollgate was located on the mountain between Wurtsboro and Bloomingburg on old Route 17. Sarah Ludlum was perhaps the best-known toll keeper, as she tended the tollgate for nearly 20 years beginning in 1879. Ludlum was a shrewd businesswoman. She opened the gate for the evening at 9:00 p.m. or 10:00 p.m. when she went to sleep, but if she knew of a dance or special affair that was taking place in the area, she would stay up and collect more tolls. Fire eventually destroyed this tollhouse in 1911. (Courtesy of the Mamakating Historical Society.)

Years ago, travelers approaching Wurtsboro on Sullivan Street from the west had to pay a toll at the village limits before proceeding into town. The horse and carriage in the center of the photograph are stopped at the tollgate. The gatehouse still stands and is a private residence today. (Courtesy of Jack and Toni Haley.)

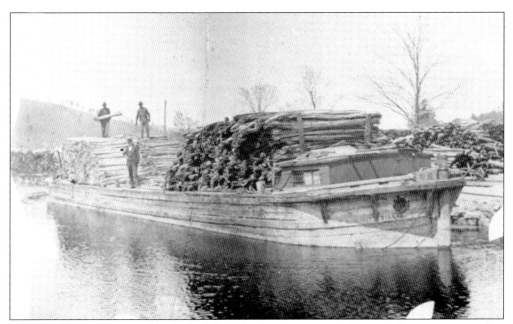

This canal boat was owned by D. B. Adams lumber company and was used to transport timber and rough-cut lumber. The initials D. B. appear on the bow just above the town name of Summitville. (Courtesy of Elizabeth Laden.)

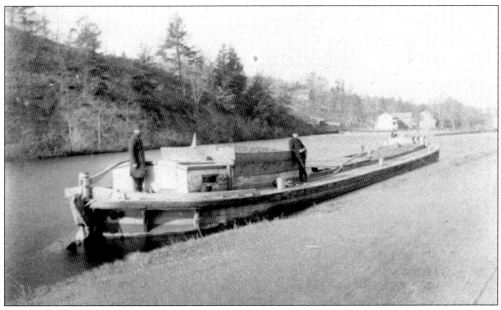

This canal boat seen making its way down the Delaware and Hudson Canal was photographed in Phillipsport. (Courtesy of Robert J. Olcott.)

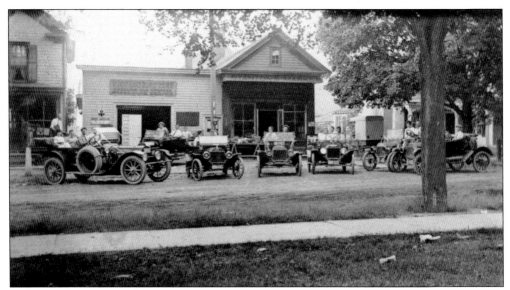

Stanton's garage was located on the south side of Sullivan Street in the middle of Wurtsboro. In this picture, employees are proudly showing off their latest inventory of Ford automobiles. Stanton's grocery market can be seen in the same building on the right. (Courtesy of Jack and Toni Haley.)

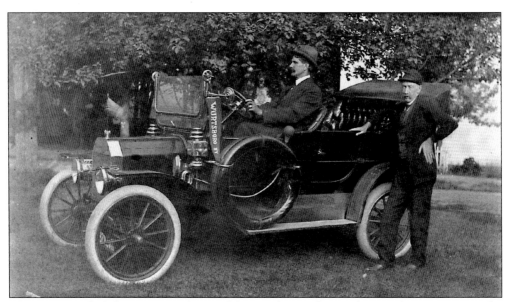

Chauncey Newkirk leans against his Model T Ford, complete with Wurtsboro pennant. The driver is unidentified, but the dog, named Sport, belonged to Newkirk's son Percy. (Courtesy of the Newkirk family.)

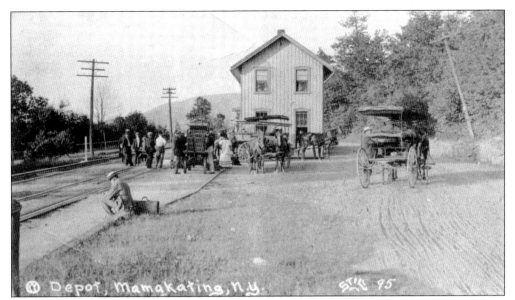

Stagecoaches and passengers await the arrival of the next train to Mamakating. Pictured are Frank McCune's stage from the Dorrance House and Seymore Masten's stage from the Ye Clarendon Inn (currently known as Danny's), which was owned by Newkirk at the time. Lee Wakeman was the train station agent and lived upstairs with his family prior to a fire in 1914 that leveled the building.

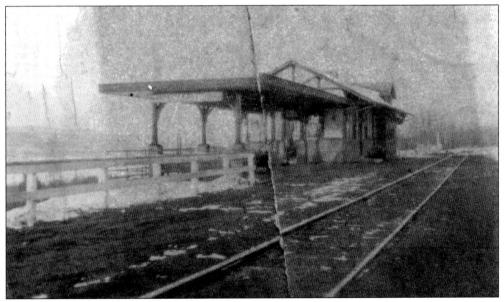

This photograph shows the Mamakating station around 1928. This was the second station that was built after the first station burned. This station still stands today and is the home of the Veterans of Foreign Wars. (Courtesy of the Lindsay-Dunn collection.)

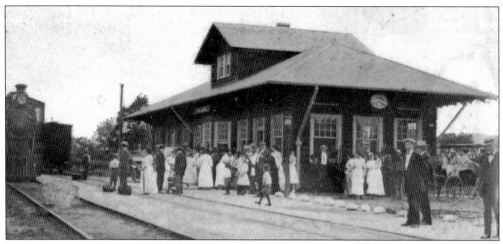

Passengers await the arrival of the train at the New York, Ontario and Western Railroad station at the eastern end of the village of Wurtsboro. The depot has been a private residence for a number of years but still resembles the old station. (Courtesy of Linda J. M. Tintle.)

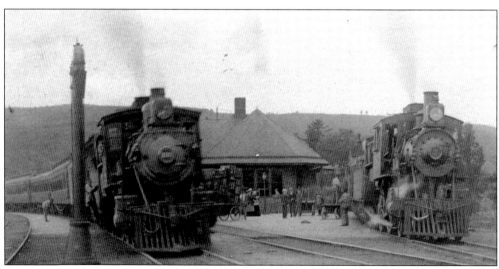

The Summitville train station was another busy stop along the New York, Ontario and Western Railroad. The train station served the hamlet of Summitville right up until the end of railroad service in the 1950s. The building sat empty for many years until it was finally razed. (Courtesy of Linda J. M. Tintle.)

This photograph depicts a rare view inside the Bloomingburg portal of the High View tunnel. The 3,857-foot curving tunnel that connected the High View station and the Mamakating station took several years to complete. It represented an engineering feat for its time as it was blasted and drilled from both sides of the Shawangunk Mountain. When the two teams met in the middle, they were only off by a few feet. The first regular train passed through the tunnel on February 1, 1872. (Courtesy of Linda J. M. Tintle.)

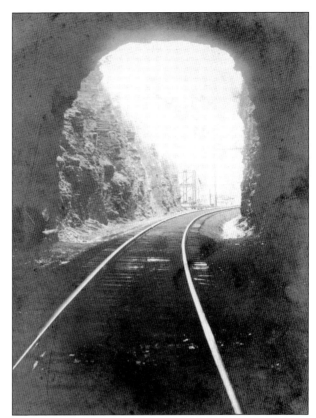

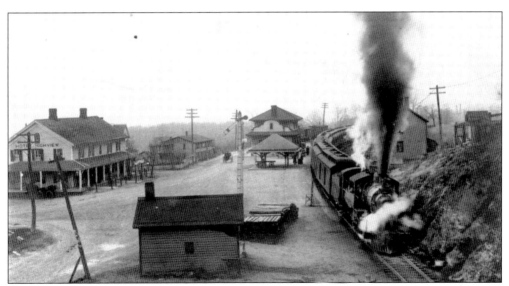

This photograph shows a steam train about to enter the tunnel after departing from the High View station in Bloomingburg. The station, partially hidden behind the pavilion in the center of the picture, still exists today, although it has been converted into a private residence. (Courtesy of the Hultslander family.)

ACROSS AMERICA, PEOPLE ARE DISCOVERING SOMETHING WONDERFUL. *THEIR HERITAGE.*

Arcadia Publishing is the leading local history publisher in the United States. With more than 3,000 titles in print and hundreds of new titles released every year, Arcadia has extensive specialized experience chronicling the history of communities and celebrating America's hidden stories, bringing to life the people, places, and events from the past. To discover the history of other communities across the nation, please visit:

www.arcadiapublishing.com

Customized search tools allow you to find regional history books about the town where you grew up, the cities where your friends and family live, the town where your parents met, or even that retirement spot you've been dreaming about.